VERMONT
PROHIBITION

VERMONT PROHIBITION

TEETOTALERS, BOOTLEGGERS & CORRUPTION

ADAM KRAKOWSKI

AMERICAN PALATE

Published by American Palate
A Division of The History Press
Charleston, SC
www.historypress.net

Cover: U.S. Customs agents at the border crossing in Swanton, Vermont. *From left to right*: Seldon Caldwel (immigration agent), Roy Seward (deputy collector of customs), Irving Bronson and Joe Walker. *Courtesy of the Vermont Historical Society (Seward Woods Papers)*.

First published 2016

Manufactured in the United States

ISBN 978.1.62619.930.9

Library of Congress Control Number: 2015956830

For Noella,
Every Dream

CONTENTS

FOREWORD

There seems to be quite the contradiction between the hugely successful craft alcohol scene in Vermont today and our history with the temperance movement and Prohibition, but given the fact that over a century has elapsed, it is no surprise that things have changed. Time has a way of doing that to even the most ill-conceived ideas, and when Vermonters are involved, all bets are off. While the Vermont Department of Liquor Control (DLC) still stubbornly clings to some antiquated laws, throwbacks to the dark days of Prohibition, the legislature and past governors have chosen a more enlightened direction for the state. Is there more that can be done by the state to promote the flourishing craft alcohol movement, or will lawmakers, during a budgetary squeeze, kill the goose that lays the golden lager? It remains to be seen whether Vermont will embrace a future where it is a leader in the worldwide artisan food and drink movement and take its rightful place as the North American Bavaria—the place where good things to eat and drink come from—or if it will miss this opportunity. As every state and all nations look for their niche in the global market, no one is better positioned than Vermont to stake that claim.

So how did we get here? Given our history as one of the first states to embrace the temperance movement and Prohibition, it would seem unlikely that we would become a world-renowned maker of beer. There was no brewing tradition in the state, and the last of the breweries we did have closed almost one hundred years to the day before the first of the new

generation would open. Other places around the country had long-standing institutional breweries that struggled to weather out Prohibition, but when they began to make beer again, the equipment was there and so were the brewers. Here in Vermont, there was none of this. Yankee ingenuity, some stainless steel tanks left over from a declining dairy industry and some folks with a taste for good beer brought brewing back to Vermont. However, it wasn't just beer that emerged as locally produced alcohol; wineries also sprung up, and so did distillers.

Perhaps the least surprising has been the renaissance of the craft hard cider producers in the state. Even though the temperance movement shut down most of the alcohol trade in Vermont, there were always apples—and left on its own, cider will turn hard all by itself. Along with the birth of the craft beer movement in the state, Joe Cerniglia of Springfield would open an apple winery in Proctorsville to make use of the excess apples from his orchard. His first batch of hard cider had a higher-than-expected alcohol content and made for a now legendary family Thanksgiving in my household, but that's a story for another time. As production issues were resolved, another product would emerge: Woodchuck Draft Cider. While it took a while for it to catch on here in the United States, draft cider has been popular in Europe for centuries. Today, we can now boast a number of highly regarded cider makers, and one would be hard pressed to find a more fitting place for the reemergence of craft cider.

Also rooted more firmly than beer in the traditions of the state are the distillers. Even though Vermont would embrace the temperance movement in the late 1800s, its location provided folks with ample opportunities to procure distilled spirits. During Prohibition, being located on the Canadian border made it possible for Vermonters to get their share as booze flowed south. During a recent renovation of a farmhouse, a trapdoor in the kitchen was discovered that most likely was used to hide the illicit trade of alcohol. The growth today in artisan distillers, and the numerous awards and accolades Vermonters have received, is reaffirming a place for our state in the hard alcohol world.

The American wine scene has always been dominated by the West Coast, but through the years, there have also been some successful wineries in the Northeast, most notably in New York. Today, the Northeast is too cold for the most common varietals of wine grapes, but with global warming, who knows what the next hundred years will bring. In the meantime, some very delicious grapes do very well in Vermont, and there have been award-winning wines produced in the state. The

number of wineries in the Green Mountain State is always growing, and in a very surprising twist, two of the wineries have even added breweries to their production.

Vermonters have always had a tradition of supporting locally produced food and drink. Whereas other places around the country are just now discovering farmers' markets and the locavore movement, the idea of supporting local producers is written into the DNA of Vermonters. So when Steve Mason at Catamount Brewing in White River Junction came to the market with beers that had the same flavors he fell in love with while traveling in Europe, Vermonters were not only willing to pay extra for these wonderful beers, but they also went out of their way to get them. Then there were Greg and Nancy Noonan, who came to the state with the idea of opening one of the first brewpubs on the East Coast in Burlington. This wasn't as easy as it sounds. In Vermont at the time, we still had on the books laws that prevented alcohol from being served at the same establishment where it was produced. This made the whole concept of a brewpub illegal in the state. Bill Mares, as a state representative from Burlington, along with Noonan helped get the laws changed, opening up the state to other brewers. It should also be noted that homebrewing was becoming more popular, with a relaxation of laws at the federal level, but there weren't really any resources in place to help guide these budding brewers. Greg Noonan would pen one of the most concise brewing guides for the homebrewer and professional alike in *Brewing Lager Beer*. To this day, the book can be found in the reference libraries of most serious brewers.

The next serious legislative battle for brewers would come with the sale of beer above 8 percent alcohol by volume (ABV) outside the state liquor stores. The craft beer movement was embracing stronger and hoppier beers, and another throwback law from post-Prohibition prevented Vermont brewers from selling these beers in the state's package stores. The Vermont DLC has always taken its lead from the legislature and, on a whole, has embraced the changes necessary to help the local alcohol scene flourish; however, very powerful neo-prohibitionist groups keep some antiquated laws on the books and prevent changes that would be both supportive and nurturing to this exciting young industry. Yet when the enforcement wing of the DLC is pictured shooting pistols on a firing line, one has to ask: When was the last time the DLC enforcers kicked down the door of an establishment serving alcohol with their weapons drawn? Prohibition?

FOREWORD

Now this foreword is probably best described as an epilogue. However, the success today of alcohol producers in Vermont is directly related to our long relationship with the temperance movement and Prohibition. It is this story that follows.

KURT STAUDTER
Executive Director, Vermont Brewer's Association

SPECIAL THANKS

First and foremost, I wish to thank my wife, Noella, without whose understanding, love and support this project never would have been even a thought. Without her, I would never have accomplished what I have been able to do. A very special thanks goes to the staff at the Vermont Historical Society who have always been been gracious with their time, advice and assistance. Paul Carnahan, Jackie Calder, Amanda Gustin and Mark Hudson have been instrumental in my historical research. I also wish to thank the staff at the Vermont State Archives who were wonderful in their patience and knowledge while researching this subject matter. Also thanks to the staff at the University of Vermont Bailey Howe Library Special Collections who have always been wonderful in assisting with my research. The advice and assistance of Scott Wheeler was greatly appreciated, and his own work in the field has been a true asset. A special thanks also to Vermont state curator David Schutz for his knowledge and advice on Vermont's history.

I would also like to sincerely thank my research assistant, Ian Toshio Miyashiro, whose assistance with sifting through the newspapers of yesteryear and creating the index was a blessing, as was his advice. The knowledge and guidance of Joshua O'Hara, Esq. and David Huber, Esq. was tremendous in understanding the difficult legal history left from Prohibition.

Finally, I wish to thank my parents, Andrzej Krakowski and Majka Elczewska; Pam and Richard Stevenson; and Ed and Elli Giobbi for pushing and inspiring me to strive and pursue my passion. Thank you.

INTRODUCTION

Prohibition. Most romanticize the speakeasy culture, where alcohol flowed freely to those who were in the know and could get past the large, barrel-chested doorman who asked for a password. Inside, it was a party like none had never seen before. Women had recently won the right to vote, and a sexual renaissance was underway throughout the country. The drinks were colorful and mixed with different fruits and syrups. The party atmosphere was spiked with the knowledge that it was illegal. This is the portrayal of the Roaring Twenties, as they were known, that has become part of our social consciousness. Unfortunately, the last remnants of that generation are fading, casting memory to a second generation for whom the stories are not so vividly recalled. As a society, we tend to remember the bright spots of history and, over time, forget the more troubling side.

Prohibition in Vermont is a dark chapter in our history. Being one of the first states to adopt Prohibition, and enduring it for the longest in one form or another, Vermont took more than fifty years after federal repeal to undo its effects. While the movement's original intent was to curb the degradation of moral and social standards and strengthen core family values with the backing of a growing religious fervor, Vermont essentially replaced one group of evils with a new set. During the roughly eighty-year stretch that the state had one form or another of prohibition on the books, the consumption and production of alcohol ceased, but a new class of criminal emerged. Vermonters exchanged public drunkenness and fervent alcoholism for rumrunning and a far-reaching black market. Along the international

boundary with Canada that spans from Lake Champlain in the west to the Northeast Kingdom corner in Canaan to the east, smuggling and vice entered the lives of many who were searching for a way to make money to support their farms and families. While some were larger-than-life characters during Vermont's period of prohibition, most were just everyday folks.

One of the understated effects of prohibition coming so early to Vermont was that a lot of money was spent out of state on alcohol and hospitality. The state's history with prohibition is often clouded by unfortunate occurrences within specific communities, especially those in the Northeast Kingdom region of the state. With the resurgence of interest in Prohibition—and in many ways, the romanticized stories of the time—the actual cultural history, the hardships and moral questions faced, have come out of focus. Many people turned to rumrunning, illicit production and, in some cases, even operating illicit businesses to make up for the lost revenue and difficult financial times at hand. Whether they were operating a line house, a smuggling wagon or, later, a car moving booze from Canada or simply trying to have a good time, everyone was in search of making money. It was not uncommon for a farmer to admit later in life that he ran booze from Canada, as evidenced in Scott Wheeler's important work capturing the oral histories of many residents late in life. In many cases, one month of smuggling earned more income than years of farming. If the barns of the Northeast Kingdom and the granite quarries of Barre could talk, who knows what stories they would tell of what happened there during Prohibition.

For Vermont, prohibition came early. While federal Prohibition went into effect on January 19, 1920, Vermont started state-mandated prohibition in March 1853. Strong religious fervor aimed at combatting increasing levels of social consumption of alcohol, combined with state politics, resulted in the second state-mandated—and longest-running—alcohol prohibition in the United States. Very quickly in the 1850s, the state was purged of legal alcohol, leaving scars on the industry that would take over a century to heal. Today, with Vermont's current renaissance in beer, cider and spirits, it almost seems as though nearly eighty years of prohibition never occurred. Unfortunately, though, for generations of Vermonters, prohibition became forever embedded in state history and family lore.

IN 1820, THERE WERE OVER two hundred distilleries in Vermont producing a wide variety of spirits. This would translate to every town having at least one distillery. In the case of St. Johnsbury, there were twenty-three distilleries

operating in the area.[1] Most Vermont newspapers ran advertisements for distilleries and even a few breweries that were either opening or starting a new season of distilling. Often, though, advertisements also showed the troubled side. It was not uncommon to see ads like the following:

NOTICE TO DEBTORS

The Subscriber most earnestly requests that all persons who stand indebted to him, either by book or note, to call and settle their accounts immediately, as he is in absolute necessity for the same. All kinds of Grain that is merchantable he will take at a fair price; likewise Beef, Mutton, and Poultry alive, will be received till the 20th of October next.

All persons who neglect this friendly invitation will have their accounts and notes put into an attorney's hands without discrimination.

JUSTUS BELLAMY

N.B. The distillery will be carried on as usual by the said J. Bellamy; and the smallest favor will be thankfully acknowledged.
VERGENNES, Sept. 27, 1798.[2]

Advertisements requesting that debtors pay their balances became commonplace. While some were polite and cordial such as Bellamy's, others were not, essentially demanding immediate payment or else judicial action would be taken. Depending on the distillery, payment was mainly in the form of grains, cider or hops. Some allowed payment in the form of beef, pork belly or ham. This frequency of debts owed to distilleries spurred both social cartoons and temperance propaganda. Many of the propaganda pieces showed the debt as one of the seven or ten steps of drunkenness.

At a time of such rampant consumption of spirits, beer and cider, a few factors have to be considered. First, our modern relationship to alcohol is completely different from that of our ancestors in the early part of the nineteenth century. For example, today, the water that flows through our plumbing infrastructure is safe to drink. Two hundred years ago, that was not the case. Fresh water was dangerous to consume. Well before germ theory became wildly known, drinking water available in the state often contained harmful bacteria and pathogens. If you didn't boil the water beforehand, it could literally kill you. Beer and spirits, however, were safe to consume thanks to the production process. Cider was created from pressing apples, also creating a safe beverage to consume.

INTRODUCTION

Aside from adressing issues of water safety, beer and cider were an important source of carbohydrates for the long and strenuous labor done each and every day. While today it is common to go for a beer or cocktail after the workday has concluded, centuries ago, alcoholic beverages were consumed all day long across the Vermont landscape. Beer and cider helped to keep laborers hydrated, as well as supplying them with the fuel needed to complete the tasks at hand. Alcohol consumption started early in a child's life, and daily consumption much later in life was commonplace.

Vermont's reputation for artisan and craft products—specifically beer, cider and distillates—has gained world renown in modern society. It was part of every town's fabric. Pressing apples every fall was important to resupply the cellars of families and towns for a difficult winter. Beer was brewed seasonally, specifically from August until the brewing supplies ran out in the winter. Artisan spirits, aged for years, were not common at the beginning of the nineteenth century. Distilleries at the time would produce their spirits and place them in barrels; the aging process was however long they sat in the barrels before being sold and consumed. This time frame could be as short as weeks or months rather than years. The whole notion of extended barrel aging—for example, three-year-old whiskey—is a more modern creation. Aging back in the day took up cooperage, as well as space in the distilleries, which was costly for the owners but is now a planned expense. Families would often have stocks of barrels that would be used season after season to store the winter's rations.

Taking into account some of these factors, it helps to build the understanding of why there were so many distilleries in Vermont. There is another side to this understanding, though, in terms of how much alcohol saturated the state. So much alcohol consumption led to a host of issues in both the health of the individual and the health of the community. While consumption steadily increased at the turn of the nineteenth century, accounts from the period express concern about loss of production on the farm and a deterioration of family values, not only in Vermont, but also across New England. Once the threat of alcohol consumption started to affect the health and livelihood of a community, opposition was swift and contagious.

1
EARLY VERMONT

Vermont's relationship with alcohol started around the time of the American Revolution. The state was renowned for the Green Mountain Boys, led by Ethan Allen. A polarizing figure of the American Revolution, Allen and his Mountain Boys met at the legendary Catamount Tavern in Bennington. During this time, taverns were practically the center of the community. They were where meals were eaten, gossip was shared or, as in the case of Allen and his crew, meetings were held. Taverns and saloons were an essential part of the community and thus enjoyed a certain social immunity—at least for the time being. It also helped that Vermont's state constitution was discussed and signed at a tavern in Windsor. At the time, Vermont was not a state but rather a republic. It became a state in 1791.

Very early in Vermont's history, laws were in place to prevent excessive consumption. On February 28, 1787, "an act for the punishment of drunkennels, gaming, and profane swearing" was passed. The law mandated

that if any person shall be found drunk, so that he or she is thereby breaved of the use of his or her reason and understanding, or the use of their limbs, and be thereof convicted before any justice of the peace, he or she shall forfeit, as a fine, the sum of six shillings, for every offence, to the treasury of the town where such conviction is had, for the use of the poor: and if the offender shall refuse to pay such a fine and cost, and not have goods whereon to make distress, he shall be set in the stocks not exceeding three hours.[3]

A second law issued the same year made it illegal for a militia officer to be intoxicated, to use alcohol to muster support or to consume it on training days. It was actually during this period that casks of beer were used to entice attendance at local militia training days. The cask, or keg, of beer was usually tapped once the training had been completed. It is from this practice that today's term, a "kegger," is believed to have been adopted.

As is always the case, laws were in place to control the sale and production of alcohol through licenses issued by county courts. There were county variances in the laws, but only in the price of fines. In chapter fifty-six, "Of Inns," in *The Laws of the State of Vermont* (1809), Section 7 states:

> *If any person or persons, not having a license to keep an inn or house of public entertainment, as is before directed in this act, shall presume to become a common inn-keeper or keeper of a house of public entertainment, or shall publicly or privately sell wine, rum, brandy or any other strong liquors; methaglin, strong beer, ale, or cider, by a less quantity than one quart of wine, rum, brandy, or other strong liqours; or by a less quantity than one gallon of Metheglin, strong beer, ale, or cider; he, she or they shall forfeit and pay for the first offence, a fine of* ten dollars, *to the treasury of the county in which the offense is committed, on indictment or information, with costs of prosecution; and so double, for every breach of this act of which he, she, or they shall be convicted.*[4]

In the weekly published proceedings of the Vermont legislature for the second week of October 1809, "a committee was appointed to join one from the Council, to take into their consideration the expediency of passing an act which may prevent the distillery of grain, or exporting the same out of the State for the year ensuing, and report by bill or otherwise."[5] Although ultimately no prohibition on distillation was passed at that time, the actions of the legislature show discord on the subject of spirits and alcohol consumption in Vermont.

At the same time, distilleries were cropping up at a remarkable pace. The distilleries in Vermont from 1790 to 1820 were making a remarkable spectrum of beverages. Cider, or cyder, was commonplace around the state and provided a steady supply for apple brandy distillers. Many advertisements filled the newspapers of the time proclaiming their wares or requesting to purchase the necessary supplies to conduct the season's production. An example of one distillery that focused on apple brandy was Hinsdill & Kirshaw in Bennington:

New Distillery.
Joseph Hinsdill & Tho: Kirshaw
Under the firm of
Hinsdill & Kirshaw,
Having erected a Distillery in the north west part of Bennington, about
two miles and a half from the Court-house, inform the public that they
mean to commence the distillery of Cyder the present season, and that they
want to purchase a quantity of Rye and Hops.
September 4, 1804[6]

Another example of a distillery that focused solely on apple brandy across the state was in Salisbury. It ran the following advertisement:

Notification.
It is hereby made known to the public that the subscriber's DISTILLERY
in Salisbury is preparing to receive cider for distillation, for which they
will give seven quarts of good first proof Cider-Brandy for every thirty
two gallons of good whole cider, delivered at said Distillery, which will
be ready to receive it by the first of October next;—and wish those who
intend having their cider distilled, to forward it as fast as convenient. The
subscribers flatter themselves that they shall be able to do justice to all those
who shall see fit to favor them with their custom, as they intend to distill
nothing but cider, and pledge that the strictest attention shall be paid and
every favor gratefully acknowledged.

JED'H Lawrence
James L. Morton
Salisbury, Sept. 13th, 1813[7]

Other distilleries were more focused on producing gin, while some stuck to producing rye whiskey and sometimes potato whiskey when the grain crop was bad. Gin production was widespread in Vermont and, based on the production documented in the Vermont State Manufacturing Census of 1820, was most likely the most-produced spirit in the state. A distillery operated by David Adams in Waterbury in 1820 produced 750 gallons of an unknown spirit (most likely gin) from a combination of rye and potatoes. A Cavendish distillery of the same year produced 991 gallons of gin from rye and potatoes. In Jericho, a distillery produced roughly 1,875 gallons of whiskey, entirely from grains. To put it into a volume that we can understand

today, the Jericho distillery's 1,875 gallons would be in the neighborhood of 9,500 modern bottles of whiskey. Most of the spirits that were produced by these distilleries were consumed within the towns and outlying places, meaning they were not often shipped. Due to the high cost of glass at the time, most of the spirits produced were put into barrels, and proprietors would fill the vessels brought by customers.

Only a handful of distilleries in Vermont had a diversified assortment of spirits available due to the resources required. Depending on the seasons and harvests, however, it was possible that a distillery would switch its production focus. At the turn of the nineteenth century in Burlington, Daniel Staniford took out an advertisement explaining that he had to make an adjustment to his product offering. In the advertisement, he wrote:

BREWERY & DISTILLERY
The subscriber has on hand a considerable quantity of GIN, of his own manufacturing of an excellent quality & allowed by the best Physicians to be as healthy as any imported liquors, which he will sell for one dollar per gallon, in exchange for any kind of Produce.
The scarcity of Barley, will prevent his Brewing the quantity of strong Beer this spring, which he had intended, but the prospects of another season are flaterring, as there are several of the first Farers who have undertaken to supply him. He intends to enlarge his works the ensuing summer, and flatters himself that he shall be able to brew as good Beer, Ale, or Porter, as any imported from Foreign Countries.

DANIEL STANIFORD[8]

Staniford's operation in Burlington lasted for about thirty years, and with the ebb and flow of the seasons, he produced porter, strong ale, table beer, whiskey (most likely rye based) and gin. The placement of Staniford's distillery and brewery in proximity to the University of Vermont also most likely helped in the longevity of the operation. Many forget that Harvard University was founded by a brewer's endowment, and breweries were believed to be an important component of students' well-being.

In the early distilling history of Vermont, from around 1789 until the 1830s, every distillery was an all-encompassing operation. While with today's technological advancements, grain is malted at dedicated facilities and is almost perfectly uniform in the degree of malting, early distilleries had to create their own malt. A malt house was one of the most important resources in a town, enabling the grains and the harvest to be transformed

into a commercially viable product. Distilleries in Vermont were also malt houses that not only served their own needs but were able to bring in revenue by malting and milling the grains as well. In the town of Peacham, for example, Ashabel Martin had an operation that malted all sorts of grains, could distill any spirit of one's preference and had a sizeable smokehouse. By diversifying the operation, there was opportunity to gain additional revenue. A later news flash of a fire also showed how saturated Peacham had become with distilleries:

> *Fire!—On Sunday evening, the Gin Distillery of Mr. Ephraim Foster, of Peacham, with its valuable contents, was destroyed by fire. It may not be improper to observe that, 27 stills yet remain in operation in the single town of Peacham. If not with "milk and honey," certainly, this land o'erflows with* Gin and Whisky.[9]

While it seems that just after the turn of the century new distilleries were appearing nearly every week in Vermont, many did not last. Advertisements in a handful of newspapers helped establish the change of ownership and transfer of equipment:

> *THOMPSON & YOUNG,*
> *INFORM the public, that they have purchased the DISTILLERY and MALTHOUSE, lately occupied by* Henry Arnold & Co.—*where they intend to pursue the business of DISTILLING & MALTING, in their various branches; where they solicit the patronage of the public. They trust they shall be able to give very general satisfaction. ***They wish to purchase 5000 bushels of RYE, CORN, BARLEY & BUCK WHEAT—for which they will pay part CASH, or exchange one gallon of GIN for a bushel of Rye, Barley or Corn, by the quantity.*
> Randolph, Jan. 25, 1809.[10]

Along with the transitions from owner to owner, there was always a desire for professional distillers. Advertisements looking for help at the distilleries were also quite common. An example of this appeared in the *Middlebury Mercury* in April 1809 with an ad by a Hinesburgh distillery, owned by Lewis Wood, looking for a distiller. The ad stated, "A Distiller, Wanted by the subscriber, a man who is well acquainted with the Distilling Business, to take the charge of a Distillery in Hinesburgh. To such an one Generous Wages will be given."[11] During this period, distilleries were grossing a fair

bit of money, and the owners and skilled distillers made sizeable incomes, according to records such as the 1820 Manufacturing Census.

Curiously, during the same period that distilleries were proliferating, there seemed to be a scarcity of breweries. Without further documentation or accounts from the period, it is hard to fully explain the reason. The process of distilling shares similarities with the brewing industry. Mash, a combination of malted grains and heated water, is created from the same method used to extract fermentable sugars for distilling. Many distillers in the state were also producing beers, such as Daniel Staniford in Burlington and Jabez Rogers in Middlebury. Most likely, in 1820, many of the more than two hundred distilleries in the state were producing some form of a beer, whether small or strong.

Another contributor to the lack of professional breweries in early Vermont was the fact that beer was being produced at home. There were many malt houses in the state, and they were not just attached to distilleries. With ready access to malt and hops, which were grown in the state, brewing beers at home or even in taverns was not difficult. In Vermont, from the 1790s through the 1820s, brewing recipes were printed in the newspapers, giving people the final tool to brew beer at home. The first published brewing recipe in the state appeared in 1797:

DIRECTIONS FOR MAKING ALE AND STRONG BEER (BRATTLEBOROUGH, 1797)

Procure a tub sufficiently large to hold the malt when it is mashed, and over the tap fasten a little wooden box full of holes to keep the malt from running out with the wort. Put two or three pails full of water nearly boiling hot into the tub first, then as much malt as you can stir well together. Thus keep putting in water and malt and mixing them well together to the consistency of a thin pudding, till the whole is mashed you intend to brew. It should be kept covered down from two to three hours, when it may be let run upon the hops, with a small stream at first. When you have drawn off what wort there is in the mashing tub, put more water boiling hot upon the malt, stirring it well together, after which it may stand one hour or till it is fine. This may be done a third time or till you have your quantity of strong beer; for small beer more boiling water (cold will do) must be put upon the malt, but the mash need not be stirred. Boil your wort with the hops very fast one hour, taking care to stir it round, that it may not boil over, which it will be very apt to do at first. When boiled sufficiently strain it from the hops and get some of it cool as soon as you can. The yeast should be put to a small

quantity of beer at first, in cool weather, about the warmth of milk from the cow; if the weather is warm, the beer must be something cooler. When that begins to ferment, which it will do in two or three hours, more beer may be put to it, and this continue to do at intervals, till nearly all the strong beer is in a state of fermentation. It may stand in the working tub from twenty four to forty eight hours, when it will be put into the barrel. As the yeast works out, the barrel should be filled up for two or three days. It may then be corked up, leaving the air hole open. In a week or nine days, the beer should all be drawn out of the barrel, and the emptyings or grounds taken out. It should then be put into the barrel again, and in a few days corked up very close till fit for use. The quantity of malt may be from two bushels to four to the barrel, the quantity of hops from six to ten ounces to a bushel of malt. The stronger the beer the larger the quantity of hops, and the longer it will be before it is fit for use. All the vessels used in the brewing must be perfectly clean, and nothing used about it that is wet with anything else. The yeast or emptyings used in fermenting the beer must be very fresh.

W.W. Brattleborough, Nov. 4, 1797.[12]

Due to the amount of cider produced in the region, it was a given that barrels would be available.

Distillation required special equipment and a level of expertise, not only to produce the spirit, but also to not explode the still. Accidents in distilleries occurred far more often than in breweries. An example of what could go wrong was the tale of John Porter. The following article ran in the *Rutland Herald* in Vermont and parts of New York in 1824:

Melancholy Event

A striking evidence of the uncertainty of life is exhibited in the late death of John Porter, Esq. of Rutland. He was tending a distillery in the West Parish, and had let off the boiling hot returns from the boiler into a cistern that was placed under the floor, over which there was a trap door, but afterwards in passing that way rather unattentively alter his great coat, he slept [sic] into the boiling hot liquor up to his hips. He extricated himself as soon as he could and jumped into a tub of cold water, from which he was taken by some persons who came to his relief, in great agony. He survived ten days, when with the greatest composure and resignation, he yielded up his spirit to Him that gave it.

Printers in this state and in the state of New York are requested to notice the above instance of mortality.[13]

Aside from the difficulties, dangers and expertise required in distillation, far more equipment was needed than for brewing beer. Equipment for making beer was readily available and, by comparison, far safer to use. It remains curious that there were so many distilleries in the state compared to only a handful of breweries at the turn of the nineteenth century.

2
TEMPERANCE

A major catalyst in the explosion of distilleries and consumption of alcohol in Vermont was the aftermath of the War of 1812. According to town records across the state, distilleries sprouted up almost overnight— to the point that by 1820, there were more distilleries than towns in Vermont. But just as there was an ever-growing thirst, there was also mounting opposition to what was seen as a general decline. Throughout New England as a whole, there was increasing concern for the deterioration of society and lower production by farms and industries. A famous example of the portrayal of the level of alcohol consumption at the time is the work *The Drunkard's Progress* (circa 1826), by engraver John Warner Barber of New Haven, Connecticut. This image was cited throughout New England in the following decades as a powerful reminder for temperance groups on the importance of their cause. The notion of *The Drunkard's Progress* was so popular that this iconic image was re-created by different artists throughout New England and ultimately printed by Currier & Ives.

Different groups coming together for a single cause fueled the emergence of the temperance movement in Vermont. The temperance crusade started to gain traction in the state around the same time that distilleries proliferated. Vermonters drank copious amounts of alcohol in their daily routines. While estimates vary on daily consumption in the United States during this period, it is generally agreed that the average adult consumed around five gallons of spirits, a barrel's worth of beer and untold amounts of hard cider over the course of a year.[14] A simpler breakdown would be around seven drinks a day per man,

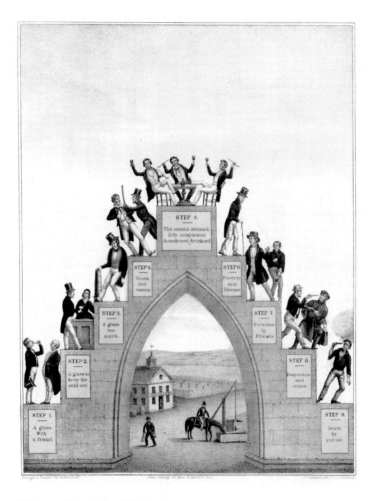

A lithograph depicting *The Drunkard's Progress*, used by the temperance movement throughout New England. *Courtesy of the Library of Congress.*

woman and child. While a few records from distilleries and breweries remain, it is nearly impossible to know just how much hard cider was produced. One record from Newbury wrote that "cider was universally drank, and in some families was placed on the table at every meal. There was a cider-mill and often three or four in every neighborhood. The old farmers consumed an amount of the beverage which seems incredible."[15] A simpler view is that people drank from dawn to dusk. There was so much consumption of alcohol that there was diminished productivity on farms and in industries, not only in Vermont, but also in all of New England. This gave emerging temperance groups a firm

cause to rally behind, and since the excess drinking hindered many aspects of daily life—from family to work—different groups of varying interests gravitated toward the fledgling movement.

As the distillery business exploded around 1820, more attention was cast on the effects of excessive alcohol consumption. Temperance groups started to officially form in Vermont during the 1820s, and it soon became a statewide movement. The first serious political actions on the prohibition of alcohol started to take shape shortly after the establishment of many local temperance groups. While no firm legislative action was taken on curbing alcohol in the state at this time, a solid foundation of support was beginning to build. It was in these emerging temperance groups where many politicians who would later become the cornerstones of prohibition formed their beliefs.

During the 1830s, many towns were petitioning the legislature to prohibit the sale and production of liquor. The state moved toward a full prohibition of alcohol in a series of steps taken over two decades, slowly cutting down production, consumption and, most importantly, sales. The dissolving of the Anti-Masonic Party in the late 1830s sparked a swelling in the ranks of the Whig Party, whose views on prohibition were extremely conservative. Through the growing strength of the Whig Party, new laws and regulations in favor of the temperance movement were quick to gain favor. While distilleries were still operating in all corners of the state, there was a large decrease in newspaper advertisements for their products. Daniel Staniford, the owner of the largest distillery in Burlington, listed for sale his brewery and distillery operation in March 1831.[16] In the advertisement, Staniford offered for sale the entire operation, the building, the stills and cooperage supplies, as well as the stock on hand. The advertisement remained in the paper for a short period of time, but it was unclear who purchased the property since there was no further record of any production at the distillery. Staniford was a prominent citizen in Burlington, having served as the sheriff of Chittenden County and as a lawyer earlier in his life. The sale of the brewery and distillery in 1831 coincided with a surge in temperance activity in Vermont, which could certainly have been a factor in his decision to sell.

Abbe Hemenway alluded to the peak period of distillation in Vermont in her writing on the town of Westminster. She wrote, "Cider mills became an institution in the parish. As the craving for strong drink was not fully met by cider in its native state, a distillery came to their help."[17] With Vermont's abundance of apples and reliance on hard cider for daily consumption, apple brandy was also commonplace. In the same passage, though, Hemenway also captured the fledgling temperance movement in both Westminster and beyond.

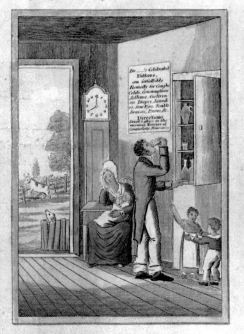
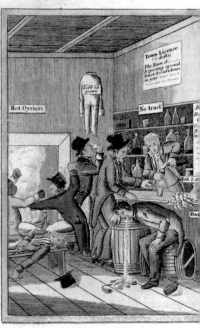

Another version of *The Drunkard's Progress* with written symptoms for each phase. *Courtesy of the Library of Congress.*

The still that was producing apple brandy in the town was sold a few years after commencing operation and "was purchased by Ebenezer Goodell, and moved into a building erected for it, near the beautiful falls on the brook, to the

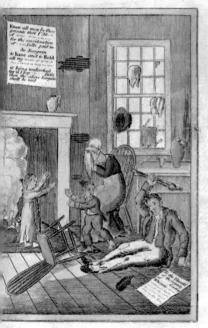

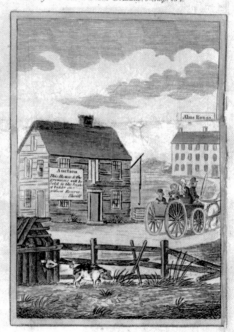

PROGRESS,

Y, WRETCHEDNESS & RUIN.

New Haven, Con. Sept 1826.

hath wo? Who hath sorrow? Who hath contentions? hath wounds without cause?.... They that tarry long at the wine. Prov. 23

The Drunkard shall come to poverty. Proverbs 23 Chap. 21 v. The wages of Sin is Death Romans, 6 Chap. 23 v.

The CONFIRMED DRUNKARD.

Beastly Intoxication, Loss of Character, Loss of Natural Affection, Family Suffering, Brutality, Misery, Disease, Mortgages, Sheriffs, Writs &c.

John W. Barber of the State of Connecticut

CONCLUDING SCENE.

Poverty, Wretchedness, a Curse and Burden upon Society, Want, Beggary, Pauperism, Death.

left of the road, as you go from the meeting-house to Charles C. Goodell's, the families in the neighborhood approving. The evil of the thing soon was seen, and some compensation was made to the owner, and the distillery disappeared about the year 1834."[18] While Westminster was able to remove the distillery from its community in a civil way, not all towns and distilleries met such an end.

One of the more likely ends to a distillery was by fire. Fires were a leading cause of the destruction of distilleries in Vermont, although rarely is how the fire started documented. In Middlebury, Jabez Rogers suffered two fires over the course of a year to his potash, distillery and brewery. When the first fire in the late spring of 1792 destroyed his entire operation, Rogers was granted a lottery by the state to raise capital to rebuild, and some residents of Middlebury and beyond donated resources to his cause. Unfortunately, shortly after reconstructing the operation, Rogers suffered a second fire that once again ravaged his operation. After the second fire in the fall or winter of 1793–94, Rogers received a reprieve from the taxes paid on distilled spirits through an act of Congress on March 20, 1794.[19] While accounts described production at his operation in Middlebury after the second fire, an 1805 article in the *Middlebury Mercury* confirmed that Rogers had rebuilt. The article notes, "Early on Saturday morning last, the inhabitants of this village were alarmed by the cry of fire which had kindled in a potash belonging to Capt. Jabez Rogers." The article further noted that "by the exertions of the inhabitants, his [Rogers] Distillery, with which the potash is connected, was preserved from the flames. Capt. Rogers has been heretofore a peculiarly unfortunate sufferer by fire. It will be recollected that it is but a few years since his Distillery was twice burnt, and property to a great amount destroyed."[20]

An example of the growing dissatisfaction toward distilleries and their destruction was documented in Henry Swan Dana's work, *The History of Woodstock, Vermont*. In it, he writes of the town's history (including an early gin distillery around 1803) and records the construction and destruction of a distillery in town:

> *Above and a little to the east of the house, and twenty rods from the road, they put up a large distillery, at which they made great quantities of gin. The casks and barrels in which this gin was put up were manufactured by Humphrey Miles, and were of first-class make. The distillery stood for six years; then, Sunday morning, November 1, 1829, between the hours of twelve and one o'clock, it took fire and was burned to the ground.*[21]

The footnote on that same page shares an interesting firsthand account of the destruction of the distillery:

> *Mr. Stearns once told me, he never engaged in any sort of business he did not like, except the affair of the distillery. This at no time went well with him, and when George Rice told him that night (Nov. 1, 1829) his distillery was on fire, a*

feeling of relief came over him at once. When the alarm reached Judge Denison's house, the Judge started forth-with for the seat of the fire, but after getting to the top of the hill, and discovering that it was the distillery burning, he turned back home to his bed. "Would have nothing to do with putting out that fire."[22]

In most cases, the destruction of distilleries by fire ended up as the news headline of the week in the local newspaper. Although there was heavy resistance to distilleries, by the 1830s, they were part of the state's landscape.

One interesting aspect of distilleries in early nineteenth-century Vermont was the fact that most were located on farms and were common among the built environment of a farming operation. Spirits were a value-added product that the farmer could produce depending on the size of his farm. All of the grains harvested had some value on the market, but turning the grains into spirits dramatically increased their value. An example of a farm with a distillery as part of the operation can be found in an 1807 advertisement for land for sale:

A Farm in the Northwest part of Peacham, on the road leading to Cabbot, Centre, containing ONE HUNDRED acres of Land—about forty under improvement—with a log house, a good barn 34 by 44, and a good, well finished distillery and malt-house.

Said Farm is well watered in general; and there is an excellent spring within six rods of the barn that is conveyed to the house, barn, and distillery, with a suffiecient [sic] quantity of water to supply them all, at any time of the year—Also, about Six Hundred Acres of Land, in Westfield. All or any part of the above premises will be sold very cheap, as owner is about to remove to the southward.

For further information enquire of the subscriber, living in said Peacham, near John Spencer's tavern.

Abel Wells
June 8, 1807[23]

Farm distilleries quickly vanished, along with other distilleries, with the rise of the temperance movement in the mid-1820s. Over a century and a half later, farm distilleries are just starting to make a slow return. Only recently have malt houses using Vermont-grown grains returned. In this regard, the after-effects of the temperance movement have been lingering in the state's agricultural industry.

One group that joined the temperance crusade in the middle of the 1820s were abolitionists and other antislavery activists. Another group that came

in staunch support were those involved in the Second Great Awakening, a period of rapid rebirth of Christian beliefs, specifically among the Baptist and Methodist denominations. Many towns across Vermont saw itinerant preachers spreading the word of religious rebirth. Middlebury College was one of the central points in the movement. Through these different groups, the call of temperance finally unified around 1828 to create the Vermont Society for the Promotion of Temperance. While different local groups had formed earlier around the state, the Vermont Society for the Promotion of Temperance had a stronger presence statewide.

One of the strongest surges in temperance activity was a series of memorial petitions calling on the state legislature to bring about prohibition. The temperance memorial petition originated in Starksboro and was created by the Starksboro Society of Friends in the fall of 1835. Over the course of the winter and early spring, many more towns sent a signed copy of the Starksboro petition to the Vermont statehouse.

In an 1836 temperance memorial copied from Starksboro, John Sanborn and others for the town of Hartford wrote to the House of Representatives:

> *The subscribers, inhabitants of the town of Hartford in the county of Windsor, respectfully represent that in their view the vending of ardent spirits, for the purpose of being used as a drink, is immoral. As such, instead of being sanctioned by receiving a liscense* [sic] *from public authority, ought to be subjected to an* [illegible] *and effectual prohibition.*[24]

The document was supported by many signatures from the town of Hartford. In the case of the Middlebury temperance memorial, it contained over two hundred signatures, but interestingly enough, eight different signatures were crossed out. It is unknown exactly why, but it's possible that those crossed off could have been determined not to be in full support of temperance or were caught imbibing.[25]

While some of the temperance memorials in 1836 were signed by both men and women on the same document, the town of Rochester had two separate copies of the same document, one for women and one for men. Needless to say, the woman had more than double the male signatures.[26]

Once these petitions were sent to Montpelier, hopes were high for bringing on legislation to curb alcohol. Upon reviewing the influx of petitions, a House committee member noted that rather than immediately ruling on the subject matter, it would be better to postpone any ruling until the next legislature. This was essentially a political maneuver to pass on the issue to the next group.

3
1853 PROHIBITION BECOMES LAW

Momentum for the temperance movement in Vermont had been building for well over a decade by 1850. What was lacking in the state, though, was a catalyst that could push the temperance efforts from discussion into law. The spark that finally ignited the building powder keg was the passage of the 1851 Prohibition Law in Maine, spearheaded by the efforts of Neal Dow, mayor of Portland at the time. The "Maine Law," as it was referred to in newspapers in Vermont, was the first law of its type to prohibit the manufacture and sale of liquor statewide in New England. It also led to serious political and social unrest over the next few years, culminating in the Portland Rum Riot of 1855. Dow was at the heart of this riot in Portland over medicinal liquor being held at city hall; a swelling of the crowd led to the militia being called, and unfortunately violence ensued. The effects of the riot prompted Maine to repeal its prohibition law in 1856.

Before the Maine Law, Vermont had started to experiment with prohibition, but at the county level rather than at the state level. The General Assembly of Vermont passed a precursor law to statewide prohibition on November 3, 1846. Known as Act 24, it targeted the licensing of innkeepers and retailers of spirits in the state, but on a county-by-county vote. It allowed a statewide vote each March, beginning in 1847, to decide whether to allow licenses to sell alcoholic beverages for that year only. The first vote in 1847 resulted in a 21,798-to-13,707 win to ban licenses in nearly all counties. Only Essex County voted to keep issuing licenses for the sale of alcohol.[27] This vote left the state of Vermont essentially dry, with the exception of

The certified results for the 1849 referendum on granting licenses to tavern and innkeepers to sell alcohol. *Courtesy of the Vermont State Archives.*

Essex County, although the ban was by many accounts a symbolic one and not readily enforced. Although the law had passed, enforcement had not been discussed, and most police and town officials found themselves in a new and unique situation. The following year's vote changed direction on the ban on licensing, with the majority of counties favoring licensing. The temperance vote succeeded again in 1849 and 1850 to turn—and keep—Vermont dry, this time with Essex County also voting to be dry.

In the fall of 1850, another step was taken toward the total outlawing of alcohol. On November 13, the General Assembly passed Act 30, which permanently banned the licensing of taverns that sold alcohol as beverages and removed the yearly state referendum. At this point, it was illegal to sell alcohol in saloons, taverns and inns. While one could easily believe that this

was the onset of prohibition, it was in reality a series of patchwork legislation that had many loopholes. There was concern about the constitutionality of crafting a full prohibition law for the state.

After passage of the Maine Law in 1851, the attitude toward temperance in Vermont at the political and social levels had strengthened significantly. One newspaper remarked, "The operations of this law were watched with eager interest by a large number of Vermonters who were dissatisfied with the legal methods provided in the state for dealing with the drink evil, and the new system soon found many enthusiastic advocates."[28] In late January 1852 in St. Johnsbury, the Vermont Temperance Society held its annual meeting, and the recently passed ban on licenses was extensively analyzed and debated. Many saw fault with the legislation, and focus turned toward crafting a new bill, closely based on the recently passed prohibition law in Maine, that would prohibit the sale and possession of alcohol at the state level. The result of the two-day meeting was a new direction in state prohibition, and a formal petition was sent to Montpelier to enact a much farther-reaching prohibition bill than what was occurring under existing state laws. Shortly after the state meeting, county temperance groups met and unilaterally endorsed the efforts of the state meeting, setting up a pivotal General Assembly later that fall.[29]

The state elections that year did not give a clear majority to any gubernatorial candidate. Votes were spread out among different candidates and exposed the erosion of the once powerful Whig Party in Vermont. The Whig Party failed to address the issue of slavery, another prominent one in state politics, allowing the Democratic Party to rapidly gain strength, pulling from the ranks of the Whig Party. On October 14, 1852, the legislature convened, and the twenty-fourth ballot elected Erastus Fairbanks from St. Johnsbury as governor, Thomas Powers of Woodstock as Speaker of the House and William Kittredge of Fair Haven as lieutenant governor. Fairbanks, a Whig and staunch supporter of prohibition, was now in a position to push legislation further. In the general gubernatorial race, Fairbanks failed to gain the mandated majority by only 609 votes.

A committee was hastily created to thoroughly analyze the Maine Law and create one that would fit Vermont's circumstances. Some members who were appointed to the committee were not keen on serving. Mr. Sherman of Montgomery requested to be removed from the committee since his view "was not so sanguine as some others that the Maine liquor law would answer the purposed designed." Representative Cushman of Fair Haven also optioned not to serve on the committee. Almost two weeks later, the

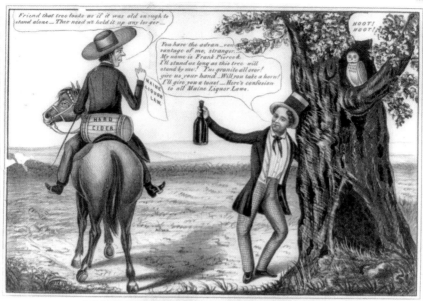

A Franklin Pierce political cartoon about the Maine Liquor Law. *Courtesy of the Library of Congress.*

committee's work was introduced to the House by General Horatio Needham of Bristol, a Free Democrat. The bill, while very similar to Maine's liquor law, included some different and important changes. It was ordered that the bill proceed, and five hundred were printed for review. Orleans County senator Bates, a Whig, introduced a very similar bill into the senate just over a week later, on November 3. During the course of the committee's work on crafting a bill for state prohibition, petitions were flooding in from all corners of the state. A total of 38,000 signatures arrived in Montpelier, of which 17,500 were by legal voters, undoubtedly giving immense support to the committee's efforts.[30]

While the bills were being considered, the push for prohibition got further support from none other than Neal Dow, the "apostle of prohibition," who came to Montpelier on November 9 and advised the legislature on temperance legislation. One week later, on November 17, amendments were presented for a bill "to prevent the traffic in intoxicating liquor." Among the amendments introduced was one that would allow the manufacturing, sale and use of "the fruit of the vine" for religious purposes, while another mandated that each town elect a liquor commissioner. Other amendments introduced were voted down in the senate.

That Saturday, November 20, there was a surge behind the law. In a series of quick motions, the bill was brought up for consideration on additional amendments. After the amendments were considered, the bill was ordered for a third reading before the senate by a vote of twenty-two to six in favor. The bill was passed the same day by a vote of nineteen to six, with a few senators absent. The passage of the bill in the senate led to Representative Porter of Cornwall recommending to the House that it abandon the House-sponsored bill and adopt the senate bill. Porter stated, "The bill was necessary, constitutional, and would be effective." In opposition to this stance was Dr. Stevenn, a Whig from Guilford. He asserted that a majority of the people of the state of Vermont had not asked for the law and that the existing law from 1850 was sufficient. He also called into question the constitutionality of the Maine Law, pointing out that it had been hastily processed and had not been examined sufficiently. A vote by the House, however, brought up the senate bill for special order on Monday by a vote of eighty-nine to eighty-four.[31]

With much anticipation, Monday, November 22, proved to be a turning point in Vermont history. A packed gallery in the House chamber saw the original House bill dismissed by a surprisingly close vote of ninety-two to eighty-eight. The senate-passed bill was then introduced to the House at about 11:00 a.m. The bill had a referendum clause attached to it mandating that if a majority of the vote was against the bill then it would not go into effect until December 1853. Very quickly, Mr. Barlow of Fairfield made a motion to postpone consideration of the bill until that Wednesday at 7:00 a.m., which would have essentially left the bill dead on the table since it was likely that the session would come to end on Tuesday. The motion was voted on and lost by a vote of ninety-four to eighty-eight.

After it was settled that the bill was to proceed, there was a quick flurry of additional amendments proposed with none passing a vote. One important change that did occur was the removal of a passage that, had it gone forward, almost certainly would not have held up under constitutional scrutiny. The passage that was removed stated that if one were to appeal his initial conviction under the law and prove unsuccessful, his fines would be doubled. The bill then came up for a third reading, after which it was immediately voted on, and subsequently adopted, by a vote of ninety-one to ninety. Loud applause erupted from the gallery of observers. Shortly after the bill passed the House, it was quickly moved to the senate, where the House amendments were adopted without issue. The bill was then swiftly taken to Governor Fairbanks for signing.

After this quick succession of events in the House and senate, a House member, Mr. Hager of Halifax, moved to reconsider the vote on the bill since he believed he had voted incorrectly, as did another member of the House. Their votes would have changed the outcome of the bill. The Speaker of the House, Thomas Powers of Woodstock, informed the House that bill was no longer in its possession and could not be reconsidered. A move by Mr. Barlow of Fairfield to return the bill to the House from the senate was passed by ninety-three to eighty-two. The vote came up in the senate to return the bill to the House, but the chair ruled that the bill could not be returned unless all the amendments were also reconsidered. A move was made to return the bill but was overturned. Before the House could further press the issue, the senate moved to put the bill before Governor Fairbanks, and he signed it at about one o'clock on Tuesday morning. In doing so, Fairbanks and the General Assembly heralded in one of the most difficult and complicated periods in the state's history.[32]

Crafted into the bill was its unique presentation to voters. The referendum presented the law to voters not as a choice of whether the bill should be upheld as law but as a choice of which date the law should go into effect. This choice was presented to voters on the second Tuesday of February 1853. The two dates that were up for consideration were the second Tuesday of March (a yes vote) or the first Monday of December (a no vote). The results of the statewide "referendum" were 22,315 to 21,794 to enact the earlier date as the starting date of prohibition. The voting fell along a geographic split, with all western counties favoring the earlier date. On the other side of the mountains, all the eastern counties, except Caledonia, approved the later one. Once the referendum for the earlier date was passed, the House of Representatives debated whether or not to repeal the law.[33] The presentation of dates as a referendum rather than the law was one of the steps taken to avert constitutional scrutiny.

The law—referred to as the "Liquor Law"—was far from perfect and was certainly not as all-encompassing as the much later federal Prohibition that would grip the country many decades later. The 1852 Liquor Law in Vermont was not a full-spectrum prohibition on alcohol; rather, it was created to combat distilled spirits. The law was much less strict on naturally fermenting liquors. Vermont's law allowed wine for religious use: "Nothing in this chapter [94] shall be construed to prevent the manufacture, sale, and use of the fruit of the vine for the commemoration of the Lord's Supper." The law also had a section that took care not "to prevent the manufacture, sale, and use of cider, nor the manufacture by any one [*sic*], for his own

consumption and use, of any fermented liquor." The clause that followed took care to ensure "that no person shall sell or furnish cider or fermented liquor at or in any victualing house, tavern, grocery shop, or cellar, or other place of public resort." A penalty was also added such that no person shall "sell or furnish cider or any fermented liquor to an habitual drunkard under any circumstances"; it carried a ten-dollar fine that was paid directly to the state treasurer. Another clause in the law was that the consumption of alcohol in one's own home was permitted as long as it did not lead to anyone's intoxication.[34]

A key provision of the law was that production of cider was permitted as long as it was unadulterated, meaning that no additional fermentable sugars were added. The reason hard cider production was permitted under the law was due to two factors. The first was how simple it was to create. Simply pressing the apples for juice would start the fermentation process in a matter of a day or two thanks to the natural wild yeasts. With the abundance of apple trees and orchards across the state, it would have been impossible to outlaw production. An example of this abundance was an advertisement in the fall of 1809 from the distillery of Benjamin Smith & Co., based in Putney, expressing that "the subscribers wish to buy 3,000 barrels of good clear cider, delivered at their distillery."[35] This was only one of many advertisements from distilleries from 1800 through the 1830s. Although the distilleries were not around, the apple trees were still producing.

The second factor in allowing hard cider production was that it was an important staple of daily nutrition. Consuming water was still a dangerous gamble, and beer produced at breweries was illegal under the law. The 1852 law, whether accidentally or intentionally, dramatically increased cider consumption in the state. It was not until about 1880 that hard cider production and consumption was outlawed in the state.

The remaining portion of the 1852 Liquor Law contained the framework of what was and was not permitted for production and consumption, the penalties and the due course of how to handle infractions of the law. While the law was constantly morphing over the subsequent decades, it did create a fairly sound guide for officials. There were allowances for alcohol for medicinal and industrial use, as well as the previously discussed home use. Also included was a section addressing adulterated liquors that carried an increased fine. A very arbitrary section of the law was giving the officer the power to enforce the law if he found the liquor to be "intoxicating" or not. Curiously, in the 1850s and '60s, by the framing of the liquor law, hard cider by many was found to be non-intoxicating, while beer or spirits were

obviously found to be intoxicating. This would lead to some dispute in the coming decades.

Statewide, there were mixed feelings over the law. Religious and temperance groups rejoiced that a liquor law was now in place and firmly entrenched in the social fabric. Opponents of the law expressed discontent not with the law itself but rather with its widespread enforcement, as well as the economic implications for towns and cities. A political observer wrote, "Among all the acts passed by the Legislature of Vermont, since its existence as a State, there is probably no one more likely to excite surprise and regret in considerate minds, than that recently enacted, called the liquor law."[36] Some even argued the constitutionality of the law itself. Suffice it to say, the law caused quite a commotion.

When the referendum vote approached in February 1853, the law nearly suffered a devastating blow. The *Watchman & State Journal* in Montpelier published news on February 3, just days before the state vote, of an event that had recently occurred in Providence, Rhode Island. Justice Curtis of the United States Circuit Court found the Maine Law, the very law that Vermont had closely mimicked, unconstitutional. Justice Curtis's ruling, read by Judge Pitman in Providence, was complicated since the case to which it was referring, *William H. Green v. Nathan M. Briggs et al.*, involved a New York citizen, Green, sending alcohol into New Hampshire. The Rhode Island General Assembly had adopted the Maine Law as its own liquor law around the same time that Vermont's General Assembly created its law. It is important to note that Vermont's law mimicked Maine's but was created by the state legislature. Rhode Island, on the other hand, adopted the Maine Law essentially verbatim.

Such a headline in the papers would have surely rattled the politicians who crafted the law scheduled to go before the people of Vermont in one week. The *Watchman* article published a lengthy analysis of the case and ruling and speculated on how it would not be the same case in Vermont. A key issue at the heart of the whole matter was that Vermont's state constitution addressed some of the issues that hindered the Maine Law's legality in Rhode Island. The heart of Justice Curtis's ruling was that the Maine Law hindered the right to appeal, something that was not an issue in Vermont's law. In fact, the provision struck from Vermont's law that doubled the fine if someone lost his appeal was the central point of contention in Rhode Island. The headlines did not prevent Vermont's liquor law from being enacted.

After the law was voted to start that same year, the political ramifications were nearly instantaneous. Vermont's gubernatorial term was and still is only

two years, meaning that Governor Erastus Fairbanks, a Whig, was up for reelection that same year, in the fall of 1853. He failed to gain a majority vote in the general election, winning only 20,708 total votes, or 43.9 percent. The runner-up in the election was Democratic challenger John S. Robertson, who won 18,142. A third challenger, Lawrence Brainerd, received only 8,291 votes. Once again for Fairbanks, the choice of who would be the next governor would head to the General Assembly when it reconvened later that fall.[37]

Many rounds of voting ballots took place in the General Assembly until the twenty-sixth ballot gave John S. Robinson, the Democratic runner-up, the required 120 votes to be named governor. Fairbanks ended up with 104 votes, or 43.5 percent. The upset of Fairbanks led to the quick deterioration of the Whig Party. Robinson served only one term and was succeeded by Stephen Royce, who served two terms. Royce was elected as a Whig in his first term but was reelected as a Republican. The Republican Party in Vermont was formed in 1854 and went on to hold the office of governor for a century. A founder of the Republican Party in Vermont was Fairbanks, who succeeded in 1861 to be elected governor of the state once more. After 1854, the Whig Party disappeared from Vermont's political landscape.[38] With Republican rule firmly entrenched, state prohibition was solidly rooted in Vermont for a long time to come.

There was irony, though, in the way Vermont's prohibition law was enacted. During the course of deliberations on amendments to the Liquor Law, special care was taken to ensure that it would remain legal to produce, sell and use wine for religious purposes. One of the issues addressed at the Vermont State Temperance Convention in 1858 was the issue of wine. The opening speech at the convention remarked:

> *That Wine is a divinely chosen emblem of Christ's body, and the juice of the grape of his blood, none will deny. Wine, too, is the divinely chosen emblem of the consolation, comforts, and life-giving power of the Gospel. On these points all D.D.s will agree.*
>
> *The Canaan promised to the faithful descendants of Abraham, was a land of Vines. And the faith of the true people of Israel was inspirited by the cluster from the vines of Eshkol. But the passages of Scripture in which the vine and its fruits are made the emblem of the life-giving and soul-stimulating provisions and consolations of the Gospel, as well as of the body and blood of Christ, are too numerous for an allusion to them here. Suffice it to say, wine under both the Old and New Testament dispention*

[sic], was the appointed emblem of the blood of atonement, and of the vivifying and soul-cheering Gospel of Christ. The only question about which our Doctors disagree, is, was the appointed emblem fermented wine. That is, was it in fact, wine, or simply the juice of the grape.

On this point, I think the church will agree, that as God has not made that point clear, we need not trouble ourselves with it, provided we can get what is in fact the fruit of the vine not corrupted. The fact that the juice of the grape can remain unfermented in a warm climate not more than twenty-four hours, it is at least, presumptive against its being kept in all places and at all seasons in an unfermented state.[39]

Out of the convention came a surprising view from the temperance movement that wine—and, arguably, cider too—was a right; temperance advocates based their argument on the religious belief that "wines such as these, God has not only permitted and approved, but positively commanded to be used."[40] Over the next decade, amendments were proposed to loosen restrictions on wine, but none ever drew serious attention. The temperance movement around the state, while advocating that the Liquor Law be more lenient toward wine, also called for a firm tightening of the law's enforcement. Enforcement would be the most difficult task for Vermont in the coming decades.

4

THE NOTORIOUS CATHERINE OF ST. ALBANS

After state prohibition was passed and on the books in 1853, Vermont had localized pockets of those opposed to it. While some voiced protest, most turned to an emerging black market created by the law. Others, though, simply refused to accept the law and were openly defiant, daring for action to be taken against them—often with swift results. The closer towns were to the international border, the more saturated they were with now-illicit spirits. In the case of the community of St. Albans, Catherine Dillon, an Irish immigrant, gave authorities more than they could handle when it came to upholding the law of prohibition.

Like most immigrants arriving in America, Catherine Dillon came to Vermont in the 1840s with her husband, Patrick Dillon, from Ireland in search of a better future. Both arrived poor, but at a time when the railroad boom in the state was creating opportunities for many, the Dillons were presented with the chance to work and succeed. According to her obituary in the *Burlington Free Press*, Catherine set up a moving boardinghouse for the laborers working on rail line construction through central and northern Vermont. The boardinghouse moved seasonally with the progression of the railroad. Catherine always had a supply of whiskey on hand and knew how to keep the booze flowing. Once the railroad lines were completed and boarding the workers was no longer viable, the Dillons settled in St. Albans.[41]

It was around this time that Vermont's temperance movement hit a fever pitch, overtaking the state legislature and ushering in prohibition in 1853. While prohibition became the law of the land, Dillon had other plans. She

very quickly became a common character in the local press due to her many encounters with law enforcement, ranging from mild infractions to far more serious offenses.

Although there were probably earlier infractions, just after Christmas 1854, the *Rutland County Herald* wrote about Catherine's woes with the law. According to the paper, Dillon, while charged with two counts of selling liquor in violation of the prohibition law, continued selling it repeatedly over many months. The prosecution's witness told his tale but refused to swear under oath about how much liquor he was buying from Dillon in St. Albans. The case took up a fair amount of the county court's time. Courts during this time traveled a circuit within their jurisdictions to hear cases in different towns and cities. Dillon's case was more a cross between justice and theater. The paper reported that "Madam Dillon has given the officers of the law a good deal of trouble, now and then, and probably has sold rum enough to float the Collins line of steamship."[42] Dillon was found guilty and issued a fine that was quickly taken care of. However, she did not pay her husband's fine, and Patrick was sent to jail. The news article discussed the peculiar witnesses of the trial and noted that the rum shop was always referred to as "hers."

It was only a matter of a few months before Catherine Dillon returned to the courts, this time accused of her third offense of selling liquor in Vermont. In another court case in April 1855, Dillon was once more openly defiant. An article in the *Burlington Free Press* noted that she was a "notorious offender of the liquor law in St. Albans." The article also noted, "Her husband has been in jail there for some time in default of a fine imposed last December for breach of law, which fine his better half refused to pay though she had funds enough to fee lawyers in abundance in her own cause."[43] Dillon's trial was once again a theatrical event; she was ultimately found guilty and this time sentenced to three months' imprisonment, as well as a $100 fine—a very stiff penalty at the time.

Although she was found guilty, the case was not quite finished yet. Just after giving his verdict, the judge asked if Dillon wished to appeal. At first, she didn't believe she would appeal her guilty verdict but quickly changed her mind and sent for another local lawyer to handle her appeal. By the time the lawyer got to the proceedings, the two-hour window that the judge had set for appealing her case had passed. Not to be deterred, she raised the point that the judge never clarified when the two-hour mark began. Once again, Dillon lost her appeal.[44]

Later that year, after she had served her three-month sentence for liquor law violations, Dillon found herself in an even more difficult bind with the

law. She returned to operating her shop in St. Albans, once again selling liquor, and once again she was caught by the police. This comes as no surprise; newspapers noted that she was the "notorious" rum-seller in town and remarked about how the town finally had a period of peace from her antics when she was serving her sentence. The new charges, however, were more numerous. A total of twenty-five violations were levied against her, and once again she was found guilty. This time, she was issued a fine of $500 and given four months in jail. Not to be out done, Dillon did not appeal the latest conviction but rather sued the arresting sheriff for assaulting her. The suit never gained traction and was ultimately dropped.[45]

The next time Dillon returned to the news was in 1857, this time not in violation of prohibition but rather getting a divorce. In court, Dillon made the claim that she was being abused. Her husband's attorney noted that he had never abused her; in fact, she was "a strong vigorous female with whom he would under almost any circumstances be wholly inadequate to cope in a scuffle & that in fact he has ever been kept in complete and perhaps commendable subjection to his wife."[46] Her obituary in the *Burlington Free Press* gave a separate and different account:

> During the time of the Civil War Catherine had become tired of her husband. It is important to remember that Catherine had befriended many railroad workers over the years and perhaps knew every railroad worker by name. She obtained a divorce from her husband, it is claimed, in the following manner:
>
> Mr. and Mrs. Dillon were returning from a trip on the cars when Mr. Dillon failed to find his valise among the baggage on the platform. On Catherine's advice he selected another bag from those in the pile of baggage for the purpose of exchanging the bag for his when his was found. No sooner had they reached home than she procured his arrest for larceny. The unfortunate man was sentenced to Windsor prison, and as a condition of his release, went out in the Vermont Cavalry Regiment as a bugler.[47]

While the account is entirely believable given Catherine Dillon's character and antics, she was already using her maiden name of Driscoll by 1858.

Just a couple years later, Catherine Driscoll returned to the papers, once again being found guilty on multiple counts of liquor law violations. She received a fine and jail time. What was curious in this instance, however, was the fact that she managed to break out of jail, and for some unknown reason she was never returned to prison, although she was still in the

community. There was some speculation and suspicion that "Catherine had well-developed relationships with those responsible for enforcing the laws and benefited from their assistance."[48] Such suspicions provide the most logical argument for why, after breaking out of prison, Driscoll could not be recaptured and returned. The fact that she engaged in the black market liquor trade also would have enabled her to pay off any officials in St. Albans.

A reoccurring theme with Catherine Driscoll was that she did not stay out of trouble for long. It seemed every run-in with the law Driscoll had only escalated in severity and brazenness. In 1862, she was arrested after police executed a warrant to search her shop and found "ten barrels and a keg of hard liquor, valued at $1,000."[49] It is unknown how much of a fine or jail time she received, but it could not have been too severe due to the fact that she found herself arrested for manslaughter after a drunken patron, Peter McQuinney, died in her saloon in 1864. But once again, the charges levied against her were suddenly dropped, and nothing more became of the incident. Curiously, there was little to no coverage by local newspapers, possibly due to the negative light that would shine on St. Albans.

All of the illicit business that Driscoll conducted in St. Albans drew more scrutiny as the years passed. While there were more minor run-ins with the law over the next three years, Driscoll landed in more serious trouble in 1867. After an investigation, she was indicted in the United States District Court in connection with smuggling liquor and her black market operation in St. Albans. She was found guilty of the charges; surprisingly, only a $2,000 fine was levied, with no jail time issued. While $2,000 was a large amount of money at the time, it is fair to say her operations were highly profitable since she quickly took care of it.[50]

Less than a year later, in 1868, Driscoll once again was at the heart of a serious incident in St. Albans. While it is difficult to get details from the time of the incident, an 1872 lawsuit that Driscoll filed in county court shed light on what occurred. In Driscoll's account, Edward and Joseph Messier attempted to assault and rob her at her shop. The brothers' account, however, states that they went to collect an outstanding debt that Driscoll owed. In response, Driscoll pulled out a pistol, and when the brothers disarmed her, she threw a pan of boiling water at them. The Messier brothers never got the money they were after. Driscoll eventually dropped the lawsuit, and there is no further record of the incident.

After troubling the city of St. Albans with saloon and criminal operations for nearly two decades, Catherine Driscoll passed away in 1872 at around the age of forty-five. In her obituary in the *Burlington Free Press*, the paper

noted, "Catherine amassed a considerable fortune, variously estimated at fifty to seventy-five thousand dollars. In her younger years she was considered handsome, but later her personal beauty had become somewhat failed, owing to the excessive use of stimulants."[51] Her estate was sizeable, and a fight ensued among her relatives over who laid claim to it that lasted for a few years afterward.

Driscoll's open defiance of the state's prohibition law left a lasting mark not only in St. Albans but also throughout Burlington and beyond. Her story shows just how broken the prohibition law was in Vermont only twenty years into its reign. While Driscoll was repeatedly caught for her actions, she was never punished severely enough to serve as a deterrent to her future dealings in the liquor trade or to hinder her resources. The handling of Catherine Driscoll raises questions about the handling of the state's prohibition law in general. Though not explicitly stated anywhere, it is obvious from the records that Driscoll had assistance from both law enforcement and town officials in getting out of serious legal trouble. Since she was able to acquire considerable wealth, evident in the fines she paid and the estimated value of her estate when she died, it would not be a stretch to think that money spoke louder than the law.

Catherine Driscoll's legend did not end after her death. The scarring from her reign in St. Albans was evident in a newspaper article published by the *St. Albans Daily Messenger* shortly after she died. There were reports of unknown sounds and sightings at the properties she owned on Catherine Street. The article, "A Ghostly Visitation," records the unusual happenings:

> *For several nights past the "spiritual rapping" have been heard in one of the tenements on Catherine Street owned by the late Mrs. Dillon. The occupants, becoming a little nervous, called the attention of the police to the fact, and officer Burgess spent some time there last evening and heard the raps distinctly, first in one place and then another, at times faint and at other times clear and loud. He could discover no cause and came away. The woman occupying the tenement, a Catholic and not over visionary, avers that soon after his departure her table began tipping and her bureau was visibly moved.*
>
> *How much of all this is to be attributed to marvelousness and fancy we do not know; probably nine in ten will say it is all that, but what will they say to this?—One of our merchants—a young man and the remotest possible from belief in superhuman appearances, says he went into his barn last evening "and whom do you suppose I saw? If I ever saw her in my life, I then and there saw Mrs. Dillon." She ran up stairs and he followed,*

with his lantern, thinking that after all it might possibly be some spirit in the flesh—of the earth earthly—whose presence in his buildings he would not care to tolerate, but he found nobody, not a trace nor an odor of the supernatural or subterranean realms. We withheld names only because we have no permission to publish them, but we give the facts, as we have them from undoubted authority. Mrs. Dillon made considerable of a stir about here when in the flesh, and whether this be now her ghostly shade or not, we think we but echo the voice of all good citizens when we repeat the immortal words of Hamlet, "Rest, rest, perturbed spirit, rest!"[52]

No further hauntings by Catherine Driscoll were recorded, but in a state known for its free spirit, her legend will always be a part of Vermont's Prohibition history.

5
THE JUG CASE OF 1889

During the course of state prohibition, one of the greatest difficulties in enforcement was the shipping of alcohol from neighboring states via the railroad. Much later, federal Prohibition had a simple focus on where the alcohol was arriving from: Canada. In Vermont during state prohibition, the state lines were porous to the point of mockery. Looking to make an example of the people behind the shipping of alcohol, Vermont found its man in John O'Neil of Whitehall, New York, in 1882.

John O'Neil was a wine and liquor merchant with a store in Whitehall. While prohibition had been in place in Vermont for nearly thirty years by 1882, at the time there was no prohibition in place in New York. O'Neil's location in Whitehall was beneficial due to his proximity to the railroad that serviced, among other stops, Rutland, Vermont. In what became known as "The Jug Case," O'Neil received many orders from Vermont through the railroad. The general method of the orders were cards with addresses and the order a person wished to place attached to a jug. At his shop in Whitehall, O'Neil would fill the jug with the order; carefully pack the jug, attaching the address to it; and ship it back on the rails "cash on delivery."

With alcohol being shipped into Vermont nearly every week, especially to places like Rutland and Burlington, the newspapers ran many notices of liquor seizures and arrests. In O'Neil's case in 1882, a warrant was issued for his arrest after a complaint was made to officials about his shipments into Rutland and other towns. After an investigation into O'Neil's dealings and shipments, he was charged with 457 offenses in trafficking liquor and vinous spirits into Vermont.

The case against O'Neil in Vermont was very complex. He was arrested for doing a legal business in another state and shipping by train to Vermont to fill the orders. The case received a fair amount of coverage in newspapers in both Vermont and New York. O'Neil was ultimately found guilty of the charges levied against him by the State of Vermont under its state prohibition law. What is rather remarkable is that O'Neil was ordered to pay a fine of nearly $10,000 in a month's time, and if he couldn't pay such a fine, he would serve three days per $1 of the fine. This would translate to a prison term of over eighty years of hard labor, or essentially a life term.

The case wound its way through the legal channels of both the state of Vermont and the federal system. Among the different arguments made was that the punishment was cruel and unusual. Ultimately, the courts disagreed since the number of charges was so great. The other argument raised in the appeals that was somehow overlooked in the initial case was that the case fell under federal jurisdiction due to O'Neil's sale over state lines. This in turn led to further appeals all the way to the United States Supreme Court in October 1891 and, later, January 1894. During the nearly decade-long process of appeals, O'Neil was still operating his liquor store in New York and appeared before the judge or officials in Vermont as requested.

In late March 1894, the Supreme Court released its final ruling on the celebrated O'Neil "Jug Case." The motion for overturning O'Neil's conviction was denied, and he faced the final sentencing. On appeal, he was found guilty of only 305 of the original 457 offenses, reducing his term to sixty years' imprisonment. Facing the judgment in 1894, O'Neil was ordered imprisoned for sixty days and to pay a fine of $6,100 for all the offenses he had been charged with over a decade earlier. Upon hearing the sentence, O'Neil declined to plead on his behalf and was taken to prison.[53]

On April 27, 1894, John O'Neil was released from prison, having served a total of sixty days and paid a fine of $6,050. Three separate times, the governor of Vermont was petitioned for clemency on O'Neil's behalf, but none was granted.[54] The case received extensive coverage in newspapers in Vermont. It also showed just how challenging Vermont's enforcement was of state prohibition.

6
VERMONT PUTS BEER ON TRIAL, LITERALLY

Due to the remarkably loose enforcement of prohibition laws in Vermont, there were many times when state and local officials tended to turn smaller events into much larger events. In some cases, an arrest on possession of a single bottle of alcohol received more attention than other town events. Rutland was a hotspot for such incidents, in part due to its being one of the few cities where discontent toward the state prohibition law was common. The city, however, had no clue what was about to happen when a keg of beer was thrust into the spotlight, bringing attention to a new beverage that made its way via immigrants to Vermont.

In May 1876, *The State of Vermont v. One Keg of Lager Beer* was tried in the city of Rutland. The case was based on a keg of lager seized on May 8, 1876, at a German café in Rutland owned by Frank Jackson. Beer fell under the 1853 Liquor Law as a banned beverage, but the law specifically outlawed ales and porters. Lager beer, a cool-brewed, bottom-fermenting beer, was new to Vermont. Due to the fact that lager was much different in appearance (far more clear) and taste (clean and smooth) than traditional ales of English heritage, it was unclear where it fell under the prohibition laws.

The case came before Justice H.W. Porter at the office of Prout, Simons & Walker on a Saturday morning. Local newspapers covered the pending case and called attention to the event, drawing a sizeable crowd to the proceedings. A key point of the case early on was the attempt to establish what level of "exhilarated" a man must be to be considered intoxicated. Under Vermont's 1853 Liquor Law, beer itself was not necessarily illegal—only beers that

were found to be intoxicating. The actual definition of intoxicating was never fully established.

Amid the hearsay used as evidence was the story of a man living in Rutland who consumed 137 glasses of said lager in one evening. Although there was no account from the consumer, a few witnesses to the event testified that they observed no "exhilarating" effects. Other eyewitness accounts of other encounters with lager beer in the region stated that nights of consuming the beverage never led to any issues.

With prosecution and a team of lawyers as defense, the case was tried in front of a jury. The owner of the café, Jackson, claimed that the keg of lager was not for sale and was non-intoxicating. The keg was tested for its percentage of alcohol and was found to contain 6 percent ABV. The doctors who presented this evidence from the testing also presented comparisons to the court: a two-year-old Vermont cider contained 8 percent ABV; Bass ale, 6 percent; lager seized from A.R. Fuller, 8 percent; and a porter ale, 4 percent. All of these were deemed to be intoxicating. According to their testing, the keg of lager from Jackson's café fell within the range of beverages that were found to be intoxicating.

The defense objected to these comparisons. It claimed that the case at hand was to decide if the keg from the café was intoxicating in and of itself, and it should not be held to comparisons.

The first witness for the prosecution was Dr. E.C. Lewis. Lewis was part of the team of doctors that tested the lager on the day of the seizure and determined the 6 percent alcohol content. After cross-examination, it was revealed that the doctors who tested the keg had found different alcohol percentages, ranging from 5 to 6 percent. In defense of the different percentages tested, Lewis testified that beer that is exposed to air starts to turn into vinegar and therefore decreases in alcohol content.

Dr. Lorenzo Sheldon of West Rutland was the next witness to testify. The doctor said that he had no knowledge of the intoxicating properties of lager, nor had he ever witnessed someone he knew become drunk from lager. The third witness was Dr. S.H. Griswold, who gave the same testimony as Dr. Sheldon.

Moving on in the case, the next witness called was Oscar Phillips of Rutland. A reporter noted that the witness "had drank; had drank a good deal." Phillips testified that when he drank lager in Saratoga, New York, he was never intoxicated from the beverage alone. He remarked that he consumed lager beer all night and felt nothing more than a touch "light-headed" and rather full. The defense never cross-examined Phillips but did comment that Phillips was "light-headed" when he started his testimony.

The last witness for the prosecution was William Powers. He testified that he had consumed lager beer years earlier in New Haven, Connecticut. At a saloon highly regarded for serving lager, his consumption had left him intoxicated for six hours after he finished drinking.

After these testimonies were heard, the defense was allowed to proceed with its witnesses. The witnesses, all of whom happened to be doctors, were sworn in to court. A newspaper article reported, "The array of ponderous experts sitting opposite the jury in a body was really quite imposing."

The first witness for the defense was Dr. E.A. Pond. Pond had analyzed the same lager beer and found it to contain 4.6 percent alcohol. He then explained to the court that he had spent considerable time studying lager beer. The study that he had conducted found that the beer was made from only barley and hops, containing a small amount of alcohol, considerable sugar and other compounds. The results of Pond's study on lager beer were that it was a powerful diuretic and, taken in large amounts, a cathartic, quite nutritious and non-intoxicating. In closing, the doctor noted, "A man may drink 15 to 20 glasses, and aside from feeling a little sleepy or stupid, feel no effects from it; it is carried away before the system has time to absorb alcohol enough to intoxicate."

The next witness for the defense was Dr. Middleton Goldsmith, a doctor who studied in Germany. Goldsmith agreed with Dr. Pond about all the properties of lager. Having spent time in beer gardens in Germany, he testified that one garden in particular had nearly thirty thousand people, according to police reports, consuming lager all day, including Goldsmith. At the time of the beer garden's closing, he went to the exit and observed the crowd leaving, noting that there were only two people who showed any effects, both fourteen- or fifteen-year-old girls. His testimony wrapped up with him noting that European countries known for brandy and whiskey production have a high rate of drunkenness and overconsumption. Germany, on the other hand, with its lagers, has a very low incidence of drunkenness. He closed his testimony by stating that he had indeed consumed the lager beer in Jackson's café and found it non-intoxicating.

Five doctors all testified then, and all maintained similar arguments to Dr. Pond's. The last witness for the defense was Dr. J.D. Hanrahan. He testified that he lived near the entrance to a sizeable lager beer garden in New York and saw huge quantities of lager beer being consumed. Hanrahan even admitted that he "frequently drank from twenty to thirty glasses in one evening and felt no effect from it." His testimony closed that he did not feel that any "man or woman with any brains could drink enough to become intoxicated."

After the witnesses for both the prosecution and defense were heard, the court adjourned for dinner. At two o'clock in the afternoon, the court reconvened, and the closing arguments were heard. The court left the jury to decide the matter; five minutes later, it reached a verdict. The verdict found that the keg of lager beer was "not guilty" of all charges in Vermont.[55]

The case was quite the opposite of an earlier case, in 1869, tried under the 1853 Liquor Law. That case was centered on the seizure of ale near the Burlington Brewery owned by Benjamin Peterson. Peterson was arrested for the sale of intoxicating beer even though his brewery, started by his father, had been operating for thirty years, dating back to 1840. His case started in August 1867, and through appeals, it came before the January 1869 Supreme Court of Vermont.

The case before the court was theatrical and based on questionable testimonies. The key witness for the prosecution was William Davis, a teamster who was employed by Peterson to carry away the beer, presumably to the docks to be shipped to Plattsburgh. His testimony stated that most of Peterson's beer "goes across the lake [Champlain]."

The next witness for the prosecution was Luman A. Drew. Drew testified that "strong beer," the type Peterson produced, was intoxicating. Curiously, Drew provided no credentials to support his authority. He admitted, though, that he had never personally witnessed Peterson producing strong beer. Through cross-examination, he conceded that his testimony was only hearsay.

Thomas Rhodes then took the witness stand and was concerned that his testimony would be self-incriminating. After the judge stated that his testimony would not be considered self-incriminating, Rhodes admitted that he had purchased Peterson beer. Roughly nine months prior to the arrest, he had purchased a half barrel of Peterson's strong beer, which was delivered to the Rutland & Burlington rail depot.

The final witness called was Edgar Burritt. Burritt, a druggist based in Burlington, was shown a bottle of beer from Peterson's brewery. Asked what the liquid was, Burritt stated that it was a "sour hop beer either strong beer or small beer" and he did not know anything further. That was all that was needed from Burritt. In Peterson's case, his beer was found to be intoxicating, and he was severely fined for his actions.[56]

In the lager beer case, the opposite occurred. Part of this was most likely a rebellion against the state's 1853 Liquor Law. It did, however, create a mockery of the case and Vermont's liquor laws in news outlets throughout the Northeast. The *Rutland Daily Globe* reported:

The Boston Globe *gets as badly mixed as does our contemporary. It says: "This is very embarrassing. The supreme court of Vermont lately decided that lager beer is not an intoxicating beverage, and now the court of appeals of New York decides that it is." Seeing that the supreme court of Vermont have had nothing to say on the matter, and the court of appeals of New York say that it is a question that a court cannot try, but must be left to a jury to determine, what is there so very "embarrassing" about it?*[57]

The paper also ran a column entitled "Lager Beer Notes: Comments of the Press" to show some of the accounts from papers in the region. One account from the *Plattsburgh Republican* noted, "A Rutland jury has decided that lager is not intoxicating. That settles the matter." The *Poultney Journal* published a couple of commentaries mocking the event. The first stated, "A wag here says he is going to keep and sell lager beer, and if it is seized he will send for the Rutland doctors and prove an alibi." The second account pointed out that "we do not know but a man can get twenty or thirty glasses of beer into his stomach in one evening and not get drunk, but we shall not risk it." The *Vermont Witness* concluded, "We learn that a Rutland jury recently gave their opinion that lager beer was not intoxicating. So much the worse for their opinion. They might get somewhat enlightened on the subject, by inquiring of some of our recently reformed men, who say they have often been made drunk on the offensive beverage, what they think about it."[58]

The summer of 1876 saw a few cases where lager beer was at the center. While the cases differed slightly from that of the keg of beer at Jackson's café, they were still attempting to determine whether lager beer was intoxicating. Only a couple of months after the first case,

another trial on the intoxicating qualities of lager beer, took place before Justice H.W. Porter on Saturday. The case was State vs. CE Stone, *for keeping with intent to sell. A part of a keg of lager beer had been seized by Deputy Sheriff George W. Crawford. A jury was demanded and empaneled. The juryman accepted were B.H. Burt, A.W. Wiggins, K.K. Hannum, A.S. Marshall, Warren S. Guilford, E.F. Sadler. The witnesses produced on the part of the state were George W. Crawford and Dr. E.C. Lewis. Mr. Crawford testified that he tested the keg and thought it contained either ale or lager. Dr. Lewis testified his impression was it was lager beer. Dr. J.D. Hanrahan was called who testified that lager beer was not intoxicating.*

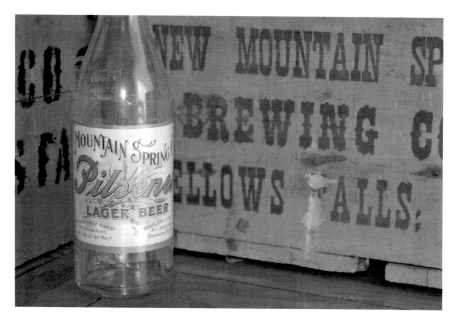

A bottle from the New Mountain Spring Brewery that set up shop literally across the border from Vermont in Walpole, New Hampshire. *Courtesy of Toby Garland.*

> *L.W. Redington, grand juror, made a brief argument in behalf of the state and P. Redfield Kendall for the defendant. The Jury after two hours' deliberation, brought in a verdict that a case was not made and that lager beer was not intoxicating.*
>
> *This is the third decision by jury that lager beer is not intoxicating, and does not come within the provision of the statute prohibiting the sale of intoxicating liquor.*[59]

Ultimately, in the coming years, lager beer was found to be, just like ale and porter, intoxicating. Right around the time lager beer was being put on trial, a brewery opened its doors across the Connecticut River in Walpole, New Hampshire, to cater to demand in the region. Lager beer joined the ranks of cider, ales and porters, non-religious wine and spirits as intoxicating and in violation of the 1853 Liquor Law in the state. Stemming from these cases were amendments that attempted to plug the leaking holes present in the dam of state prohibition. Unfortunately, they only added to creating discontent toward the laws in many communities.

7
ENFORCEMENT, SOMETIMES

The tales of Catherine Dillon and the O'Neil "Jug Case" were just the tip of the iceberg in terms of the difficulties of enforcing state prohibition. Each additional high-profile case tended to bring new alterations to the 1853 Liquor Law, creating a complicated spider web of legislation. Enforcement was an even more complicated issue since it was handled differently across the state during prohibition.

Court records from the second half of the nineteenth century prove that enforcement was loose and highly fractured. Some county courts record, during certain decades, the heavy prosecution of minor infractions followed by periods of prosecuting only a handful of cases over the course of a year or two. In the years just after the 1853 Liquor Law was passed, there was a sharp decrease in minor infractions such as public intoxication and disorderly conduct. A June 1854 report from the grand jurors to the court stated, "We are informed by the present high sheriff of the county who has had the general supervision of the jail for the past two years and the present year that the prisoners during said time have gradually decreased till the present term of the court and for the first time for several years past the jail has been entirely free from prisoners."[60] Similar reports were found in both newspapers and county court records around the state. The quiet affairs of the courts were short-lived, however, once the now-illicit alcohol started flowing into the state.

An unintended result of the Liquor Law and state prohibition was regular citizens turning into criminals. Some, such as Catherine Dillon, were never

going to stop their pursuit of making money from selling illicit alcohol. Many other upstanding citizens found themselves in court over the possession of alcohol. Court records from Caledonia, Orleans and Franklin Counties list schoolteachers, farmers, merchants, lawyers and laborers as being found guilty of violating the law and most often paying ten-dollar fines for their first offenses. Most never appeared before the courts again. Others, however, appear yearly throughout the records, such as B.F. Stanley, who was found guilty of intoxication for a third violation of the law, fined twenty dollars plus costs and sentenced to sixty days of hard labor in Rutland.[61] Fines were the most common punishment, with jail time ordered only if the fine was not paid. Jail time as a penalty in addition to fines started to enter the records at the end of the 1870s almost uniformly across the state.

The sporadic enforcement was not lost on many communities. During the decades after the Liquor Law was passed, there was mounting discourse over its handling in most counties. Alcohol was still flowing through the state, and the social deterioration cited by temperance groups was still occurring in areas. Key phrases such as "habitual drunkard" and "known seller" were fairly common in the public records. Sometimes the frustration toward enforcement was vocalized to the courts. In Franklin County Court, the grand jury stated to court and county officials in June 1865, "There seems to prevail a great indifference on the part of the local magistracy towards the illegal traffic in intoxicating liquors. Aside from the poisonous consumption of the liquors so sold, the increase of their illegal sale should excite general attention and alarm on the grounds of public health as well as morality."[62]

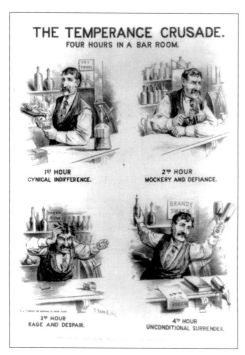

A temperance propaganda poster of what could happen to tavern owners. *Courtesy of the Library of Congress.*

By 1870, enforcement of the law had started to gain

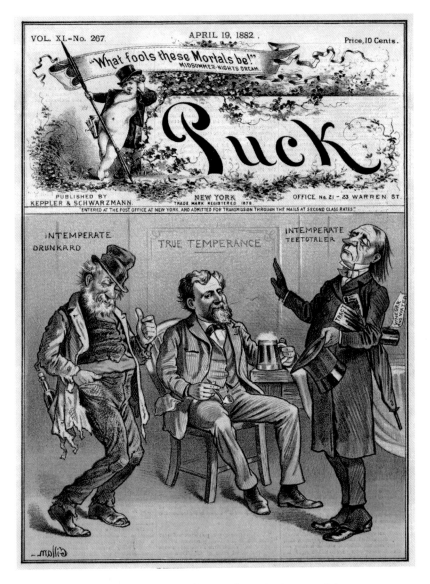

This cover of a popular magazine depicts growing attitudes toward the temperance movement nationally. *Courtesy of the Library of Congress.*

momentum, albeit sporadically. Anytime a police raid was conducted, it gained coverage in the local papers. When these raids turned up heavy stocks of liquor that were seized, they made headlines, with town officials pointing to their success. The following passage from the *St. Albans Daily Messenger*

about a series of New Years Day raids conducted in the city in 1870 is an excellent example of the propaganda that stemmed from such raids:

Heavy Seizures of Liquor.
THE TEMPERANCE MEN AT WORK.
Down with Rum, Up with Law.

The new year was commenced here not only with "good resolutions" but with vigorous works, and judging from the character of the men engaged in them, and from the strong support which they receive from the less active but not less respectable and determined portion of the community, they are likely to be continued at least throughout the year.

About 2½ o'clock Saturday afternoon, Sheriff Place and Constable Failey, with Mr. Place's son and W. A. Cooper as deputies, and two or three guards, having numerous complaints and warrants in their pockets for the seizure of liquors held for sale contrary to the prohibitory law, commenced operations on Lake Street, and continued work until sun-down, as late as it was supposed they could legally proceed that day. The Following is a list of their seizures:

From Geo. Claflin's billiard saloon, 11 packages, consisting of barrels and kegs, some of which were full and others partly full.

From Kennedy McGrath, who kept a little tobacco, some oysters and a good deal of rum, first door above Gilmore & Brainera's [?] livery office, 12 packages, consisting of several full barrels, one or two kegs, and one or two jugs.

From Michael Sullivan, who keeps a grocery just below the St. Albans House, 8 packages, consisting of casks and cases of bottled whiskey.

From Wm. Carney, who keeps a grocery under Williston's tobacco store in Driscoll Block, 10 packages, consisting of full barrels and one or two jugs.

From Tierney & McCarthy, at their house, 5 packages, consisting of one barrel and four kegs. Their place of business, being closed, was not searched.

The entire amount seized made six double wagon leads, and is estimated at about six hundred gallons. It was stored in the cellar under Stone & Foster's store, and legal investigations will soon determine whether or not it is subject to confiscation.

Further seizures will be made, and fairness as well as law and temperance require that the work shall be thorough. It may not all be done at once, but there are three hundred and sixty-five days in a year, and those who have the matter in hand will work as opportunity favors or occasion requires.

These seizures have made considerable excitement, and all the usual comments on both sides have been evoked. Some few have been so silly as to

threaten the persons or property of those whom they conceive to be the prime movers, but all such will do well to reflect that there are not only laws for the protection of all citizens but also laws against threatening. These men are not to be intimidated. They—or at least some of them—have faced greater dangers. In this matter they have foreborne long to do what they felt to be an argent public duty. They have not now undertaken it to desist through fear, and the only thing to be apprehended is that—as has been the case so many times before—they will by and by become "weary in well doing." They say not, however, and even if they should "faint and fall," there are others and still others to take their place.

Now as to the sellers, we in common with the general public regret that they have sustained this loss of property. We would not like to deprive any man of a single cent against his will, even for the best of purposes. But they have as a rule been very indiscreet. They have sold to everybody, drunk or sober, who offered them money, and the result has been that nearly every day men could be seen staggering through our streets. We believe that a sentiment of toleration for our hotels has been very widely cherished among temperance men, and we have heard no complaint against them for extensive or indiscriminate selling. If there is any excuse for any one to violate the law, the hotel proprietors have it, for they daily entertain people from all parts, and have a commendable desire to afford the utmost hospitality and cheer which the tastes of their guests may crave. But of course they cannot expect immunity in anything prohibited by law, even if tolerated for their benefit by public sentiment, and should they in this case be found in the category of the unfortunates, it will be only a repetition of the old story of "poor Tray."

All we have to say in addition is, that we hope this demonstration will not prove to be simply a raid. We have seen them before, and believe they result in no permanent good but considerable private injury. Let the work be vigorous and continued. If there is profit in rum selling, temperance men may depend that it will be continued in every nook and corner that is not watched. Eternal vigilance is no more the price of liberty than of temperance.

Now what shall be the public verdict? Let good people remember that the foe they have assailed is not weak, nor cowardly, nor scanty of expedient. He is armed with everything but right and law and will assail those whom he counts as enemies in all the walks of life. If our people would maintain law and order, security to life and property, good prospects for the young men and prosperity to the whole, they have but one word and deed the men who have begun this new year this important work, remembering, in whatever emergency, that "thrice is he armed who hath his quarrel just."[63]

Headlines such as this were not common and acted more as moral support for the enforcement that did occur. What this article unknowingly foreshadowed was the statewide tightening of enforcement over the decade of the 1870s. The following are selected articles from the 1870s documenting the difficult tasks of police officials in the enforcement of the liquor laws:

The Rutland Liquor Raid [1874]

The liquor raid in Rutland was renewed on Wednesday. The principal point of attack was the residence of Mr. B.H. Wooley, where nine barrels of cider were seized upon and carried away, which Mr. Wooley claims is the property of Mr. Duane Johnson of Stockbridge, left there for storage. The officers also secured a couple of barrels of liquor from Miss Mary Meldon, and a small quantity at the bar of A.R. Fuller, on Centre street; also some little amount of the "ardent" at Centre Rutland. There was no crowd or excitement. All the liquor seized, except that owned by S.J. Loop, was, after a hearing by Justice Marshall, condemned, and the greater part of it being found unfit for use was destroyed.[64]

Liquor Raid in Eden [1875]

On Monday Deputy Sheriff Stevens, proceeded to the inn of Benj. Scott, with a warrant to search for liquor, seize the "critter" and arrest the owner. Mr. Scott was informed of his business, and showed him into his bar, and a small quantity of liquor found. Stevens then proposed to go down cellar to make further search, but to this Mr. Scott demurred. The officer expressed a determination to go down, and Mr. Scott was equally determined that he should not and informed him that he would never live to get down there. Stevens said he should go down or die, whereupon Scott collared him and called for help and his family gathered around and indulged in language more vigorous than elegant, but the determined officer was too much for them, and soon rolled out of the cellar hatchway about 200 gallons of old Kentucky and Ohio bourbon valued at nearly a thousand dollars. Scott was arrested on charge of selling and about a hundred witnesses subpoenaed. The trial was had yesterday, before justice Stevens when a plea of guilty of eight offences was entered. Scott was fined $80 and costs, bot amounting to over $130, and appeal taken.[65]

Teetotalers, Bootleggers & Corruption

Raid on Liquor Sellers [1876]

Sheriff Morrill had thirteen warrants placed in his hands this morning, directing him to search the premises of certain supposed venders of liquor. He and his deputies have made a thorough search and have seized over $1,000 worth. The seizures are as follows: From G.N. Williston, a large quantity of lager beer, ale and porter; O.O. Smith, a considerable amount of ale, lager, and liquor; Dr. Thibault, brandy and gin; Aleck Massey, brandy and gin; Stephen Bassford, lager beer and stock ale; John Patneau, gin and whisky. John Audrews, Albert Jones, Mrs. Mann, John Brown, Kennedy McGrath and John Murphy were also visited, but nothing was found on their premises.[66]

While these raids to enforce the law proved to be fruitful, they most likely represented just a fraction of the amount of alcohol present in the communities during this period. Even as the raids increased, the fines and punishment remained the same until the end of the decade, when the penalties became stiffer.

As enforcement of the Liquor Law noticeably increased, there were unfortunate circumstances that stemmed from the crackdown. While there was a split among native Vermonters in terms of their stance and views on prohibition, the state did have localized populations of immigrants who had made Vermont their home. Burlington, for example, had a sizeable Irish population, while Hardwick, Barre and Ryegate all had large Italian populations stemming from the granite industry. Caledonia, Orange and Washington County have noticeable numbers of immigrant names in court case records. Although it would be unfair to claim that the local police specifically targeted the immigrant populations, their cultural differences toward alcohol created a difficult situation. A case that came before the Caledonia court in 1905 against an Italian, Giscomo Bardelli of Hardwick, addressed these cultural differences. Bardelli's attorney noted, "It is custom of the Italians to keep wine and beer and sometimes stronger liquors for family use, and to use it upon their tables with their meals." The attorney noted that the witness who testified for the prosecution against Bardelli "testified under a feeling of ill will and prejudice...towards the Italians in Hardwick."[67] Bardelli lost the case and faced a stern fine of $600.

A firsthand account of what was occurring in the city of Barre under the 1853 Liquor Law came from famous anarchist Emma Goldman. While traveling around the United States in 1899, she stopped in Barre in January to give a series of four lectures. Her host for her stay was Salvatore Pallavicini, the editor of the Italian-language section, called "Parte Italiana," of the *Barre Evening Telegram*.[68] After her stay, she wrote:

> *Vermont was under the blessings of Prohibition, and I was interested in learning its effects. In company with my host I made the rounds of some private homes. To my astonishment I found that almost all of them had been turned into saloons. In one such place we came upon a dozen men visibly under the influence of liquor. Most of them were city officials, my companion informed me. The stuffy kitchen, with the children of the family inhaling the foul air of whisky and tobacco, constituted the drinking den. Many such places were thriving under the protection of the police, to whom part of the income was regularly paid. "That is not the worst evil of Prohibition," my comrade remarked; "its most damnable side is the destruction of hospitality and good-fellowship. Formerly you could offer a drink to callers or have one offered to you. Now, with most people turned into saloonkeepers, your friends expect you to buy booze or to buy it from you.*
>
> *Another result of Prohibition was the increase in prostitution. We visited several houses on the outskirts of the town, all doing a flourishing business. Most of the "guests" were traveling salesmen, with a sprinkling of farmers. By the closing of the saloons the brothel [be]came the only place where the men coming into town could find some distraction.*
>
> *After two weeks' activity in Barre the police suddenly decided to prevent my last meeting. The official reason for it was supposed to be my lecture on war. According to the authorities, I had said: "God bless the hand that blew up the Maine." It was of course obviously ridiculous to credit me with such an utterance. The unofficial version was more plausible. "You caught the Mayor and the Chief of Police in Mrs. Colletti's kitchen, dead drunk," my Italian friend explained, "and you have looked into their stakes in the brothels. No wonder they consider you dangerous now and want to get you out."[69]*

After Goldman's departure from Barre, copies of her planned fourth lecture were printed and disseminated throughout the area. The account of her stay in Barre is a rare look into what was actually occurring in

the community and how officials were in the midst of breaking the very law they were supposed to uphold. This type of interaction would also explain some situations, like that of Catherine Dillon in St. Albans, where the enforcement and penalties were highly suspect.

In Barre and Hardwick, though, something different also occurred during prohibition. Many Italian women in these cities lost their husbands to the granite quarries and the illness, known as silicosis, that stemmed from breathing all the granite dust. To support their families, many widowers turned their homes and living rooms into cafés, serving their cooking and often wines and spirits, just as Mrs. Colletti had done.

A political cartoon of the barroom of destruction. *Courtesy of the Library of Congress.*

Later cases at the turn of and just after the twentieth century, in both Washington and Caledonia Counties, featured many Italian women who were cited to appear for violation of the Liquor Law.

Enforcement of the 1853 Liquor Law was in many ways a dark spot in the state's history, not because of the raids and arrests made, but because of how corrupt and loose it was. Many upstanding citizens and families had their names tarnished over infractions of the law under questionable proceedings. Vermont was so saturated with alcohol during state prohibition that one can only wonder what effect the law really had.

8
THE 1902 ELECTION AND THE FALL OF PROHIBITION...SORT OF

The 1902 gubernatorial election in Vermont was the turning point in prohibition that many hoped would come. Up to this point, with fifty years of state prohibition on the books, there had never been any real threat to the establishment. Prohibition was a strong asset of the state's political machine, namely the Republican Party. With the Whig Party's collapse immediately after prohibition became law, the Republican Party gained a strong hold on politics that suffocated any opposition. What happened in the election of 1902 was a challenge not from opposition outside of the party but from within. The fracturing of the Republican Party was stabilized at the expense of sacrificing prohibition—at least in theory.

The Republican Party had put its support behind the nomination of John G. McCullough in the hopes of maintaining the party's powerful hold on the Vermont political landscape. The challenger in the election was Percival Clement, who was running as a Republican but also on the Anti-Prohibition Party ticket. While the election looked similar to previous recent gubernatorial elections, with a Republican forerunner with generally mild to moderate opposition, this election took a different turn.

Percival Clement was a native Vermonter, born and raised in Rutland. After completing his education at Trinity College in Hartford, Connecticut, he settled back in Rutland to help operate the successful family marble business. While the family business was Clement's primary focus, along with his growing family (he had a total of nine children with his wife, Maria), political aspiration started to form. While still running the marble business,

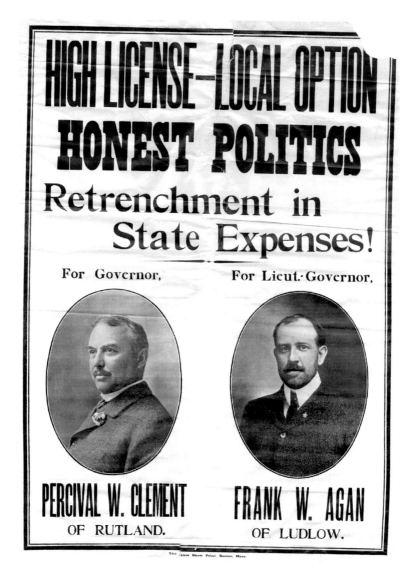

A political broadside from the general election of 1902 in support of Percival Clement and Frank Agan. *Courtesy of the Vermont Historical Society.*

along with serving as president of the Clement National Bank and investing in many railroads, he served in the state House of Representatives as the representative from Rutland in 1892–93. It was with his political influence during his only term in the House that he was able to have the city of Rutland recognized as a separate entity from the town of Rutland. A few years after

his House term, in 1897, Clement was elected mayor of the city of Rutland. After again serving only one term, he returned to his business affairs. But his leave from the political limelight was short-lived, as he returned to Montpelier only two years later, this time as a state senator from Rutland County. After a single term, Clement yearned for even a higher office: governor of Vermont.

During this period of his life, Clement invested an extensive amount of time, resources and personal fortune into the anti-prohibition movement. Just as the temperance movement had gained momentum earlier that century as a response to the excessive alcohol consumption that was dotting the landscape, the anti-prohibition movement was gaining extensive support across the state as people rallied against the strict prohibition laws. While support of the anti-prohibition movement was not strong enough to overthrow the political establishment in place, advocates were able to keep the topic of ending prohibition in the news and political conversations.

While the temperance movement rode the gathering religious fervor known as the Second Great Awakening, the anti-prohibition movement garnered support from both the waning of religious activism that emerged mainly in the aftermath of the Civil War and a series of recessions and economic panics in the decades that followed. The financial instability in Vermont started to create resistance to the political establishment. Coupled with the lingering effects of the "Long Depression" from the 1870s into the early 1880s, during which some railroad companies and many banks collapsed, Vermont's economy was hit rather hard. The loss of railroad development and construction stunted economic growth and left the state extremely reliant on outside markets. All of this led to people questioning the state government's plan and laws.

As a prominent member of the anti-prohibition movement, and considering his political and business interests, Clement saw two primary issues with prohibition. First were the political ramifications that affected the state. Clement strongly felt that state prohibition, brought into place by the Whig Party, was a gross overreach by state government into the daily lives of Vermonters. This was his first and most prominent platform. With this view, he was heavily lobbied by both politicians and citizens to run as an alternative to the Republican Party's nomination of McCullough. Clement embraced the opportunity and declared his candidacy for governor, running as a Republican but on the ticket as the "High License Option" or the Anti-Prohibition Party. The second issue Clement had with prohibition was the fact that many towns and cities heavily relied on the revenue from the anti-alcohol laws, creating a dangerous codependency.

The "High License Option" was the rallying point for the Anti-Prohibition Party, espousing the belief that Vermont's state government should remove state-mandated prohibition and instead let local town and city governments decide whether they would be wet or dry. If the town or city voted in favor of prohibition, the same law that was already in existence would continue. If the city or town voted in favor of lifting prohibition, then it would be allowed to issue a handful of liquor licenses within the town. Along with the restriction on how many could be issued, the licenses carried a high annual fees. The revenue raised from issuing these licenses would come back to the municipality for infrastructure development and improvement. While this proposed plan had many supporters, and many pointed to the dire need for infrastructure improvements, not all saw this possible new source of revenue as a positive aspect.

In a speech given in opposition to the "High License Option" in St. Johnsbury during the gubernatorial election of 1902, an unknown minister preached, "A man not altogether temperate said to me recently that old prohibitionary law has gone to the devil, hasn't it. Well, that were indeed deplorable but not half as deplorable as that the people of our state should go to the Devil also."[70] The speaker also pointed out, "In his argument during the construction of the referendum, one man said he didn't want the money that was paid for licenses, to build roads with, for it was blood money anyways." Later in the speech, the speaker also noted, "Another man said he didn't think most of the towns would care whether it was blood-money or not so long as they got it [money for infrastructure]." The speaker proceeded to take offense at such a suggestion. He continued, "Can it be possible that there is a man or woman living within our borders who could take pleasure in riding over road, however so beautiful, when those roads are paved with the broken hearts of drunkard's wives, and the sighs and sobs of drunkard's children."[71] The fiery rhetoric continued in an attempt to shame anyone who thought that the "High License Option" was a positive idea moving forward.

Percival Clement, however, was the driving force behind the plan. Clement announced that he would be running with Frank W. Agan of Ludlow. Agan, also a businessman and inventor, is best known for creating the Agan Vacuum, an early two-person vacuum cleaner. In the first political speech after announcing his candidacy for governor, Clement brought prohibition to the forefront on the evening of April 12, 1902, at an overflowing town hall in Bethel, Vermont. The nearly two-hour-long speech railed against the state legislature for its history of killing local option bills, as well as the history of what had happened to Vermont

during the near-puritanical period of state prohibition. The core of this issue, though, was that "the patronage of prohibition was part of the political machine and its position seemed impregnable."[72] Much of the revenue coming into towns and cities was reaped from the enforcement of prohibition laws and dubious penalties and fees.

The prosecution of prohibition-related arrests was quite profitable for a town. In 1898 in Rutland, the total fees charged for a sheriff, judge and other expenses came to $30.80, a substantial amount of money. It was not uncommon to have upward of nine such cases in a day.[73] Burlington and Montpelier were no different and often saw a weekly flux in prohibition-related arrests and fines issued. Earlier in the century, with the first precursor prohibition laws voted in in the late 1840s, fines were commonplace almost from the start. Bliss Davis, a state's attorney for Caledonia County from 1848 to 1850, was aggressive in pursuing prohibition law violations during this time, and case records from the Caledonia County Court are littered with guilty verdicts and fines from $10.00 to $20.00 on each count, along with the resulting court fines.[74]

The issue of fines and zealous prosecution over the decades also swayed Clement's views and the speech he gave in Bethel. The start of his speech gave a brief general background of the history of Vermont's state prohibition and the after-effects of the law on town and state politics. He then launched into what would be the core of his political message in the gubernatorial race:

The function of government is to control the individual as little as possible, allowing him the greatest freedom in all directions and only limiting his action where it interferes with the rights of others. We don't dispute that intemperance is a vice, but prohibition does not supply the remedy. We are not all endowed with the same moral perceptions. Thank god for that. And the question of what constitutes intemperance must be settled by each individual for himself. What would be intemperance in one person would be temperance in another. A man may go through his whole life eating moderately, smoking moderately, drinking intoxicating liquors moderately—in fact taking all the pleasures and business of life in moderation; he is a temperate man. On the other hand, a man may be a glutton, intemperate in nature and action, a crank in his ideas on all subject; but, if he is a teetotaler, the prohibitionist calls him a temperate man and denominates the other as being intemperate. The prohibitionist, while he is not always able to control himself even in the matter of drinking intoxicating liquors, seeks to control his neighbor, not by precept and example, not by argument and moral suasion—that

process is too slow to suit his ideas of progress, and besides sometimes his neighbor tells him to mind his own business—but the prohibitionist seems to think it is his business to attend to that of his neighbor; so he gets the prohibitory law, and with that in his hand he looks over his neighbor's fence of a morning and says: "I've got you now where you can't drink whether you want to or not," and proceeds to tell him that it is a crime to be visited by penalties, only next in severity to those that are inflicted upon murderers, to sell a glass of cider, and that is a vice and sin, which will damn his soul forever to one drink.[75]

He later moved on from this point to argue that the prohibition law that came into effect in 1853 was from a previous political landscape that had vastly eroded away by 1902. During the nearly fifty years that passed, the original law had grown in reach and authority and, Clement argued, had vastly constrained the citizens of Vermont. In a speech that was prepared by S.J. Beatty, originally to be read at the state gathering of Republicans but suppressed until after the event, Beatty made a point of supporting Clement's views that "unclean politics in Vermont are largely due to the demoralizing influences emanating from the prohibitory statute and it is the duty of every man who has the welfare of the state at heart to register his vote and use his influence to regenerate the state. A political and not religious revival is what Vermont needs."[76]

The second key point that Clement made in his speech in Bethel and carried through his candidacy was how Vermont's state prohibition law dissuaded construction and investment in new hotels and different types of businesses. He cited one such incident in 1901 where the investor was prepared to commit $200,000 to construct a magnificent large hotel on the waterfront in Burlington. After reviewing the laws, the investor informed Clement that he was looking elsewhere to construct the hotel due to the fact that he was "liable to 50 year's imprisonment for selling a bottle of wine" to his hotel guests. The investor ultimately constructed the new hotel in New York on Lake Champlain. Clement noted, "Should you be in the upper part of the city of Burlington you can look across Lake Champlain and see the roof of his new hotel."[77] This example is one of many that show how much revenue was lost out of the state and proves a very important point. It is impossible to know exactly how much of a shift in Vermont's economy occurred due to the lost revenue during prohibition.

In six short weeks of political maneuvering and many public speeches, Clement moved the issue of prohibition and the possible solution of

local option to front and center. Clement's political wrangling and the political platform on which he was running meant that no mater who took the gubernatorial election of 1902, the winner would be holding the prohibition issue squarely on his shoulders and would be responsible for whatever outcome occurred. John McCullough, the mainstream Republican candidate, had taken up the High License local option cause within his own platform. While Clement was more aggressive in the repeal of state prohibition, as well as in letting the towns decide for themselves whether to be wet or dry and issue liquor licenses, McCullough was far more conservative—to the point that he supported local option only for political gain and not necessarily out of personal belief.

With the significant attention to prohibition repeal at the forefront of the election, it was no surprise how close the election ended up being. By the time of the general election, which took place on September 2, Clement had gained significant ground on McCullough. The results of the election were much different than those of previous gubernatorial elections. The *New York Times* ran a story in the August 31, 1902 issue that had the headline: "Campaign in Vermont; Bitter Contest in That State to End Tuesday. Fight Between McCullough and Clement Republican Factions—Legislature May Have to Name Governor." The article went on to state that the governor's race "was the hottest political campaign in the history of Vermont."[78]

With the subject of prohibition being at the core of the election, the mainstream Republican nominee, McCullough, received 34,968 total votes, or 45.6 percent of the vote, while Percival Clement received 31,864 votes, or 40.3 percent. Felix McGettrick, the Democratic Party's nominee, came in a very distant third, with 7,364 votes, or 10.5 percent. The results did not give any clear winner in the election since election rules in the state required 50 percent plus a one-vote majority to win. This result meant that the legislature would be the deciding group of the election when it convened the following month.

The legislature came to a decision on the first ballot taken. McCullough was voted in as governor with 135 votes, which equated to 61.2 percent of the vote. Clement received 59 votes, or 22.0 percent, and McGettrick got 45 votes, or 16.8 percent. It came as no surprise that McCullough would be voted in as governor since he was the Republican Party–backed candidate, while Clement was running as a third party candidate. Many newspapers leading up to the election had speculated that Clement's only real chance at gaining the governorship was winning the general election outright. The difference between the general election and the legislative one were striking.

The general vote results showed that while McCullough pulled most of the Republican vote, Clement pulled votes from across party lines. Clement received support from those opposed to prohibition, as well as Republican and some Democratic votes. The core of McGettrick's support was from his own Democratic Party and much of the Prohibition Party due to the latter's outspoken dislike for both Clement and McCullough, who was pulled into taking a mild stance toward the repeal of Prohibition.

The legislative vote, however, was far more straightforward, with the Republican Party throwing all its support behind McCullough. The divide in the legislative vote was more between Clement and McGettrick; Clement received more than four times the votes that McGettrick received in the general vote but got only 4 percent more in the legislature. The vote was most likely reflective of how Clement's campaign rhetoric irritated many in the Republican Party. It was the first election since 1854 that the Republican nominee did not win a clear majority.

Similar results occurred in the lieutenant governor's race, where the Republican candidate, Zed Stanton, received 47.2 percent of the general vote to Frank Agan's 38.1 percent, and Elisha May, the Democratic candidate, received 11.4 percent. When the legislature voted, Stanton received a clear majority, winning the lieutenant governor's seat.

Even though Clement lost, he managed to pull enough support and attention that he left Governor McCullough facing a complex web of issues. In McCullough's inaugural speech, delivered to a joint session of the legislature on October 3, 1902, he wasted minimal time before tackling the issue of prohibition. After a formal acceptance of the governor's seat and praising the state's tried-and-true political system, the first issue he tackled was prohibition, announcing that the people had spoken and the future of the state was moving away from complete prohibition to a restrictive high-license local option. In his speech, McCullough stated:

> *The verdict of the freemen of the State on September 2d last was in favor of the General Assembly framing a local option and high license law and submitting the same to the people for their adoption or rejection. This duty will require the very best efforts and the most intelligent consideration of the members of the Assembly. For fifty years prohibition has been the policy of the State. The mandate comes up now from, the people to their legislators commanding them to formulate and to submit to them for their decision some other system.*
>
> *This, the Anglo-Saxon, the American method. It is the rule, of the majority. And primarily, on this subject, it must be borne in mind that all*

sumptuary legislation must be supported by public sentiment to be effectual. In framing a statute the General Assembly will have the benefit of the legislation on the subject of eight or ten of the other States. Experience is the very best guide. In every State the difficulties arising from the United States internal revenue laws, from the freedom or interstate commerce guaranteed by the National Constitution, and from the medicinal and industrial demand for alcohol will always embarrass the enforcement of any law.

Different States and different parts of the same State may require different treatment. Unlike most of the States, Vermont has few manufacturing centers or large municipalities; the great majority of her towns are rural and agricultural. Massachusetts is more nearly similar to Vermont than any other State and from her legislation probably more valuable suggestions will be derived than from any other source. But in the legislation of no one State, only, should we look for the best and wisest provision and those most suitable to the circumstances of our people.

In any local option or license system, it is worthy of consideration whether the vote on License or No License should be taken in any town or municipality oftener than once in three or five years; whether it should not be taken at elections specially called for that purpose and not at any regular election. State or local; whether if License be voted, it would not be wise to require the petition of a majority of the property holders in any block or square of a municipality before issuing a license whether a majority of the legal voters of any town or sub-division of a city should not be allowed to remonstrate against licensing or continuing the license of a specified person whether any license should be granted for more than a year; whether the number of licenses where authorized should not be limited to one for every 1,000 inhabitants, and prohibited within a limited distance of any church, school house, theater, opera house, public building, park or other public place; whether all licensees should not be required to give am bonds, and every applicant for a license furnish evidence of citizenship and good character. As to the licensing body or authorities, it has been well said that judicial purity and reputation for purity are far more important than discreet licensing.

It is of the utmost importance that courts and judges should be kept as far removed from politics as possible. This matter of licensing therefore should be entrusted to some other department or to boards specially raised up for that purpose, and which boards should have stability and independence. There should be several grades of license fees depending on the size and population of the towns or cities; and the traffic should be made to raise large revenues for both the State and the towns or municipalities.

Every licensee should be restricted from selling to minors or intoxicated persons, or on Sundays, election day or any legal holidays, nor should he be allowed to furnish musical entertainment of any kind or billiards or cards or any game whatever; and the place should be wide open to inspection from the street or highway and the hours should be strictly limited, and the shorter the better, provided public sentiment supports these restrictions.

If druggists' licenses are to be granted at all, they should be entrusted only to registered pharmacists who should be authorized to sell only in small quantities and only on the written prescription of a physician not interested in the store. These suggestions, gathered from many sources, may be of some value in formulating a proper statute to be submitted to the people for their adoption or rejection.[79]

Through his inaugural speech, McCullough laid out a rigid framework for how the proposed law would take the place of prohibition. Through debate in the House and senate, a local option bill was crafted, and on December 11, 1902, Act 90 was passed. The act, "An Act to Regulate the Traffic in Intoxicating Liquor," gave towns the right to vote at their annual town meetings on whether to be wet or dry, as well as on what kind of license the towns would issue if they voted wet.

The way the act was presented to the public is also important. The legislature added that Act 90 would have a public referendum scheduled for February 3, 1903, that would allow voters to pick the date the law would go into effect. A yes vote in the February election would allow Act 90 to go into effect on the second Tuesday in March of that year. A no vote would mean the act would go into effect on the first Monday in December 1906. The way the referendum was formulated, there was never a choice of whether the law should be passed or not but merely which day the law would go into effect. The additional three years would have given the legislature time to find a viable alternative to and method for repeal of the act. The resulting February referendum vote resulted in a yes vote by 29,711 to 28,982.

During the period between the passing of Act 90 and the referendum in February, Vermont looked like it was in the midst of another political campaign. Posters and broadsides were created both for and against, with many groups rallying their members to vote one way or another. One slogan that popped up in defense of prohibition was:

Men of Vermont, be loyal and true! Vote against the saloon. Remember the wife; remember the mother; remember the sweetheart; remember the daughter.

They are asking you now to stand by them—to leave the rum and stand by them. Not one is asking, but all are asking—every woman in our fair State! Does she not care? She does care, for none knows better than she what wrecks the home, what separates the hearts, what brings poverty, suffering, crime. Green Mountain Boys, do your duty; vote against the saloon.[80]

Other slogans were in support of repealing the high license law. Most newspapers had headlines either in support of or against the act, and given the short time between the votes, groups moved quickly to get their messages out.

A rallying cry for many in support of high-license local option was the issue of revenue. The concept of lost revenue—in this case, during fifty years of prohibition—is something that has been grossly understated when looking at the economic damage. This revenue leaving Vermont placed more reliance than ever on agricultural and business pursuits that ultimately were unable to make up such a gap. Ironically, at the time state prohibition was established in 1853, one of the leading agricultural crops was hops. The production of hops in Vermont peaked in 1860, seven years into state prohibition, which was remarkable since only one brewery was producing beer in the state at that time. The total amount of hops produced in 1860 in Vermont ranked second in the nation, creating a much-needed cash crop for the state. But between the onset of the Civil War, which eroded brewing capacity nationally; a series of difficult growing years in the mid-1860s; and the added costs of sending the entire Vermont crop to other markets, the hops industry rapidly declined within a decade. In less than twenty years after the onset of prohibition, Vermont's hops industry was no longer commercially viable, leading to yet another agricultural void and, more importantly, a financial void for farmers who were reliant on the crop. Thanks to prohibition's direct influence on Vermont's hops industry, it would take over a century for it to become even close to commercially viable, albeit on a significantly smaller scale.

It was not just Vermont's hops crop that was hard hit. Alcohol production was heavily taxed by federal and local governments, producing revenue. The loss of production in Vermont due to prohibition meant that revenue sources for the state dried up literally overnight. Taxing alcohol, aside from hard cider, was something that had always caused a stir in Vermont among distillers and brewers, but it was never really challenged.

Another lost revenue source in Vermont was tourism. With all the surrounding states and Canada being wet, the 1853 law put Vermont at a gross disadvantage for generations. While Vermont was picturesque and

often portrayed as an outdoorsman's paradise, the fact that it was dry had a significant impact on tourism. Not all businessmen were willing to stand by the wayside of Vermont's degraded hospitality industry. Many pushed the idea of temperance houses and hotels as family-friendly destinations. In some cases, the price paid for being caught serving alcohol was not a deterrent.

In Burlington, one of the largest and grandest hotels from the late nineteenth and early twentieth centuries was the Van Ness, located at the corner of Main and St. Paul Streets. Vermont governor Urban A. Woodbury, a leading citizen of Burlington, purchased the hotel in 1881. After acquiring the hotel, Woodbury went on to be elected mayor of Burlington from 1885 to 1886, then lieutenant governor in 1888 under William P. Dillingham and, ultimately, governor from 1894 to 1896. He was later appointed by President McKinley to a special commission to investigate the War Department, stemming from the actions it took in the recently fought Spanish-American War. Throughout his political endeavors, Woodbury oversaw his hotel. He defiantly served alcohol openly at the hotel, even though Vermont was still under prohibition. Most likely due to his political connections, as well as the fact that a few American presidents stayed there as guests, Woodbury never had too many legal problems. Many other proprietors in the state were not as daring or open about serving alcohol.

Many towns and cities in Vermont had concerns about saloons opening in their towns or neighboring ones and what happened to the money being spent. Joseph Nelson Harris of Ludlow printed a pamphlet that was in full support of McCullough for governor over Clement, but he also pointed to some of the effects of local option at a local level in terms of revenue. In his pamphlet, he noted:

> Ludlow has a population of about 2,000, with about 600 voters, a little less than one in three. It was shown in our Republican town caucus, that about one-third of the entire population gave Clement a majority, and were in favor of local option. With such a law, to work on the basis of similar laws in other states, Ludlow would have two saloons, and the price of the licenses would undoubtedly be fixed by a county commissioner and would perhaps range from $250 to $1,000 each, according to whether it was a first or second grade license, and out of this sum the state would be entitled to a commission ranging from fifteen to twenty-five per cent. It does not seem as though Ludlow could afford to have saloons on the basis of the income derived from two licenses. What profits could be derived from the liquor traffic in this town, would illustrate those of every town in the state.

> *Many of the voters have the idea that this is* optional *whether we have a saloon in our town or not. That is very true, but if we vote no license and Cavendish votes for a license, the liquor customers of this town would give the benefit of their money to Cavendish or, if the case were reversed, the people would pay their money to our saloon-keepers.*[81]

Looking at many publications for or against local option, few really grasped what Harris published: the effect on local economics rather than religious or social implications. While many towns launched full-on campaigns to prohibit saloons, others were pushing for them.

February 2 2 , 1919.

Received 2 00 Ballots to be used in town meeting March 4, 1919, on the question of the sale of intoxicating liquors, and 5 sample ballots.

Signed *Mary L. Benjamin*
Town Clerk

Town of *Woodbury* 71-

SAMPLE BALLOT
Shall license be granted for sale of intoxicating liquors in this city?

Yes ☐ No ☐

Shall licenses of the fifth class be granted in this city?

Yes ☐ No ☐

The voter shall make a cross (X) against the answer he desires to give.

A 1919 sample ballot to vote for local option and the town result card.
Courtesy of Vermont State Archives.

The resulting vote in the referendum on Act 90 resulted in a cultural split in Vermont. While a resounding majority of towns voted in favor of the delayed 1906 date, which ultimately meant a no on Act 90, towns with significantly larger populations voted in favor, pulling the vote over to the 1903 date. This vote also reflected the fact that the 1902 law benefited cities and towns with larger populations, which also meant areas where more tourism was possible. The law granted one license per every one thousand residents, meaning that many of the smallest towns in the state were not able to get licenses while the greatest-populated areas were able to have multiple establishments. Not all larger populations voted in favor, though. St. Johnsbury, a stronghold of the Fairbanks family, opted to vote in favor of remaining dry for years after local option was on the books. Places like Burlington saw a needed boost in local option since it meant that the city was no longer at a disadvantage in the hospitality industry during prohibition.

The result of the election did get noticeable attention in the press. Even though McCullough had won the seat for governor and removed formal prohibition, Percival Clement was the recipient of praise for dislodging the half-century law:

PROHIBITION SUPERSEDED IN VERMONT

After clinging to prohibition of the liquor traffic for half a century—for a longer continuous period than any other State—Vermont has repealed the law and adopted in its place local option and high license. Fifty years ago the prohibitory law was adopted by popular vote by the slender majority of 1,171, and last week it was voted down by a majority of about 1,600. The new system will take effect in March. "Vermont by its vote raises itself out of a mire of hypocrisy," says the Brooklyn Eagle, *but the Providence* Journal *remarks that "in a State which has given a Presidential candidate more than 40,000 plurality, the majority of 1,600 for high License looks paltry enough, and must be taken as an indication, that the issue is still open." The* Burlington (Vt.) Free Press, *which opposed license, declares that "the one gratifying feature for the opponents of the new law is that the margin in its favor in the popular vote is so small that its advocates will recognize their system to be on its good behavior, and the abuse of license will certainly cause a revulsion in popular feeling sufficient to overthrow it."*

Some papers remark that the real test of the high-license sentiment in Vermont is yet to come. The real sentiment will be revealed next month, when each town and city shall settle for itself whether it will have license or local prohibition, says the Rutland (Vt.) Herald.

"The dark night of prohibition is over. Vermont, this morning, is a part of the great world of intelligence, commerce, and wealth. We are no longer a peculiar people. We would be foolish to anticipate an easy road at first. The transition from one system to another is always attended by friction. To change the figure of speech, you can not make an omelet without breaking eggs, and you can not right a wrong without a disturbance. But we believe that there is stamina enough in the Vermont character to meet the responsibilities of new duties to which it is called with wisdom and self-restraint."

Much credit is given to Mr. P.V. Clement, of Rutland, for the result. He started the agitation against prohibition last fall, had a pledge put in the Republican platform to submit a new measure of this kind to a vote of the people, and then ran as an Independent Republican against Gen. J.G. McCullough, Regular Republican, who was elected by a small majority. Mr. Clement stood for high license and General McCullough for the prohibitory law. The Springfield Republican *comments:*

"Prohibition is still available wherever wanted, and probably two-thirds or more of the towns of the State will hold to it at the coming town-meetings. The cities and large towns, where liquor has been sold freely and often openly, in defiance of law, will generally choose a license policy, which will simply mean a regulated, revenue-producing traffic in liquor, in place of an illicit, lawless, and demoralizing sale conducted on a scale that the license policy will find it difficult to exceed. A system of high, restricted license like that of Massachusetts has been provided, and that it will prove as satisfactory in Vermont as it has in this State, we have little doubt. Anyhow, those places which do not want it need not have it, and in the application of this principle of local option is to be found the surest method of dealing with the liquor question."

The law provides seven classes for licenses, to be granted at fees ranging from $1,200 for a saloon to $10 for a druggist, who can sell for medical purposes only. Each town voting for license may have one open bar for each 1,000 population, exclusive of licenses granted to summer-hotels and to drug-stores. With Vermont out of the prohibition column, there remain but four States in which prohibition prevails, namely, Maine, New Hampshire, Kansas, and North Dakota, and in the second of these—only the sale at retail (not the manufacture) is prohibited.[82]

The local option referendum and Act 90, in the form that McCullough proposed and saw through the General Assembly, did not last long. Act 90,

passed in 1902, was effectively removed in 1904 due to its being too narrow in scope and limiting the power to issue penalties. Act 115 of 1904 removed nearly all the laws in place and substituted new broader-reaching laws, still keeping in place local option.

An example of one of the changes that occurred between 1902 and 1904 was the length of sentencing of those convicted under the law. Under the 1902 statute, the length of sentencing was limited to a maximum of three years' imprisonment. Under the 1904 revision, which took effect on March 1, 1905, the limit on punishment was lifted. This change from a maximum sentence to judge's discretion, with no limitations, was a move to strengthen the law in the public's eye. At the time, there was also what was known as the alternate sentence. If a judge issued a fine for a violation of the law and the guilty party could not pay the fine within thirty days, in many cases while imprisoned, the monetary fine became a prison sentence. While there were guidelines in places for judges that stretched decades back, the judges now had the ability to impose fines and jail time at their discretion. Some cases after this important change saw appeals based solely on cruel and unusual punishment.

An example of this change was reflected in the case of *The State v. G. Ceruti* in Caledonia County Court in December 1909. Ceruti was caught in possession of liquor at his home and was fined $300 for his initial guilty plea, which he attempted to change to a not-guilty plea. Ceruti thought he would get a small fine, which would have been less than the cost of a lawyer and proceedings. The $300 fine meant that if he did not pay, he could face 1,200 days in prison or more.[83]

While local option loosened the former prohibition laws, there was concern among lawmakers in Montpelier that the sale of liquor would deteriorate the social fabric. The overhaul of local option did, indeed, put more deterrents in place for potential lawbreakers, but in doing so, the legislature succeeded in ending state prohibition only in name. By widening the legal ramifications and at the same time heavily restricting the rules for obtaining saloon licenses, prohibition was essentially still in place everywhere except in larger population centers in Vermont. Many communities never had saloons reopen in their towns due to populations that were too small to meet the one-thousand-people minimum. Other towns and some cities had such strong local temperance movements that the vote never passed in favor of issuing saloon licenses.

What did change, though, in the revised act was that there was more governance on the county level in the form of a county liquor commissioner

who issued saloon licenses. The cost of certain licenses, whether for a full-fledged saloon with consumption on site or simply a license to sell liquor or even lesser beer and hard cider, also increased. The cost of yearly licenses led to saloons in certain locations not being commercially viable if neighboring towns also had saloons. In some cases, some towns wanted no part in the evil of having a saloon.

The statistics of arrests for intoxication over the final four years of state prohibition and public intoxication over the first four years of local option tell the story of what concerned lawmakers on all levels. In many counties, the arrests climbed during the infancy of local option. While Addison County had only 14 arrests over the four years before local option, it had 53 arrests in the four years after. Chittenden and Rutland Counties had the biggest swing in arrests. In Chittenden County, there were 545 arrests, while Rutland County had 396 arrests over the last four years of prohibition. Once local option arrived, Chittenden rose to 1,917 arrests, while Rutland increased to 1,147. In Chittenden County's case, the swing was nearly a 400 percent increase in arrests. Washington County, which had the most arrests during the last four years of Prohibition, with 485, had only 544 arrests during the first four years of local option, a relatively small increase.[84] While these statistics were fuel for many temperance groups, they did little to show the larger problems of local option.

Over the next decade or so, the question of local option or statewide prohibition would play out in the court of public opinion in Vermont. Some towns flipped back and forth, while others were firmly planted in one camp or the other. While the political landscape was drastically changed from the time of his prior attempt to win the governorship, in 1918 Percival Clement finally won the seat that had eluded him in 1902 and 1906—just in time to usher in a new wave of problems.

9
A DANGEROUS ERROR

E ven after local option became the law in Vermont and saloons finally
started to reopen after a half century, the illegal sale and production of
alcohol did not stop. While local option provided a legal means to purchase
and consume alcohol, the law was still extremely restrictive. The rather
oppressive restrictions that local option put in place were, for many, still a
form of prohibition. This led many to seek out alcohol either across the
international boundary in Canada through smuggling or via other means.
Unfortunately, there were more than a few tragedies that occurred in
Vermont due to the black market trade of alcohol in the state.

A main cause of poisoning at this time and through the end of federal
Prohibition was tainted alcohol. The alcohol we consume is ethyl, or grain,
alcohol, although different sugar can be fermented and distilled, creating
products such as rum or sorghum whiskey. Grain alcohol can also be turned
into industrial spirits, being distilled to a very high percentage. To combat
the consumption of strong industrial spirits, many were denatured by adding
either bitter compounds that made the alcohol undrinkable or by adding
wood or methyl alcohol. Wood alcohol was also used as a solvent and, in
the late nineteenth and early twentieth centuries, was known as "cologne
spirit." Ethyl alcohol, when consumed by humans, gets broken down into
the body and released. In the case of methyl alcohol, which is often cheaper
to purchase since it is not meant to be consumed, consumption often leads
to death. As the body starts to break down the alcohol, it creates byproducts
that, instead of being released, become concentrated. Signs of methyl

alcohol poisoning are blindness, organ failure and extreme damage to the nervous system. This usually occurs over a couple days.

Unfortunately, when ethyl and methyl alcohol get mixed up, it can lead to horrible consequences. The town of Richford, located on the international boundary with Canada in Franklin County, suffered one of these tragedies. The White family operated a drugstore in Richford and were known in the community. Around November 28, 1905, two men from Richford, Marshall Bliss and Nelson Royston, died from consuming wood alcohol. It was later learned that Mrs. Mary Legrondeur, of St. Armond, Quebec, had also passed away at the same time from what was believed to be wood alcohol consumption. Through investigation by the police, the source of the tainted alcohol was found to be the Whites' drugstore. The story sent shock waves through the newspapers around the state. Wallace W. White, along with his son Almon and daughter Eva, was charged with three counts of manslaughter, among other charges. The stomachs of Bliss and Royston were removed and dispatched quickly to Burlington as state evidence in the mounting case.[85]

The case was presented before the grand jury of the Franklin County court. The evidence presented alleged that the Whites' drugstore had a history of illegally selling liquor and used this as the base of the case against the Whites. The charges levied were focused on Almon White, while his sister and father faced serious but lesser charges. Ultimately, there was some public sympathy for the Whites in state newspapers. Bail for Wallace and Eva, but not for Almon, was provided by a group of citizens. The final verdict was that Almon White was guilty on four charges, and he was levied a $2,000 fine or the alternate sentence of six thousand days in prison.[86] With the revised local option law in 1904, the original caps on sentences related to prohibition were lifted, leaving Almon White with a more severe penalty for his crimes than he would have received the previous year. Another part of the local option law was the use of alternative sentences for those who could not pay their fines in a fairly short period of time. For Almon White, the alternate sentence was three days for every dollar of the fine, which meant a jail term of just over sixteen years. While White appealed to the state Supreme Court in Montpelier, his verdict was upheld.[87]

Almost immediately, Wallace White started to petition not just in Franklin County but also in the entire state to have his son's sentence reduced. After a year, the petition had been circulated around the state and was sent to Governor Fletcher Proctor asking that the case be thoroughly reviewed and a lesser sentence or possibly a pardon issued. It is worth noting that

Wallace received only a guilty charge for selling alcohol, and Eva's case was ultimately dropped. Only Almon was charged with the deaths and levied a large fine that ultimately ended in jail time. On April 28, 1909, the petition to Governor Proctor appears to have succeeded, with White receiving a pardon and being released from the Rutland jail where he had been serving time. Ultimately, White served just over three years of his more than sixteen-year sentence. The case was still a point of interest, in terms of the circumstances surrounding it and the outcome, in the local newspapers for nearly a decade. While it was never disclosed, it's likely there were more deaths related to consuming the wood alcohol mistakenly sold by the Whites to other individuals.[88]

While this was a statewide news event as it unfolded, it surprisingly never brought much attention to the issue of adulteration of alcoholic beverages. A spirited article simply titled "Intemperance," published in the *Middlebury Register* on December 8, 1874, detailed a lecture given in Burlington discussing the evils of alcohol. Although many of the numbers were grossly inflated in regards to alcohol consumption, the article did mention a litany of books and publications available to help people produce spirits at home. These recipes often contained chemicals to add that would mimic the flavors of the spirit they were trying to copy. The 1853 Liquor Law did dictate strict penalties for adulteration of alcoholic beverages, but it was an afterthought. Unfortunately, there would be problems ahead for Vermont.

Tragic events such as the White case also ignited renewed efforts to reintroduce prohibition to the state. While at the state level, local option held firm, changes did occur at the local level. Few towns in Vermont remained entirely wet or entirely dry during the period of local option:

> *"PROHIBITION DON'T PROHIBIT."*
> *Barre, Vt., July 9, 1908.*
>
> *Prohibition don't prohibit. At least this is what many "wise acres" tell us. Of course it don't; an axe won't out; a saw won't saw; a mowing machine won't mow, at least without some propelling power to assist.*
>
> *Since May first this city has been under the operation of a no license law; it should be stated however that in the town of Middlesex, about seven miles from here, there is a licensed whiskey hole, and we reap the benefits (?) of the same; I called upon the City Judge this morning (who by the way is a Good Templar) and from him obtained the following facts as to the results so far as they showed in his court; I found that for the two months of May 1907, there were 45 arrests for drunkenness and for June, 40; for the month of May*

1908 there were 2, and for June, 6. Is there any significance in the above figures? We think so; and yet I have no doubt you can find many a wise one who would tell you "there is as much liquor sold in Barre today as ever"; well if there is, it must be a different kind of goods, and doesn't have such an effect on people as the kind sold last year, judging by results.

It was remarked by Judge Scott this morning "there's no use talking, any one can see the difference by walking up and down our streets, in the good order prevailing as compared with the drunkenness and disorder under license conditions of a year ago."

At the Republican State convention held at Montpelier last week, after praising the operation of the miserable "Local Option Law," in their next breath they demand a change in the law in several respects, one of which is so that a town voting "yes" cannot grant a license to sell on the border line of the town and near some other village or city as is the case with the only license granted in this county, said licensed place being several miles from the village in the town granting it, and but a little over a mile from the City of Montpelier; another is providing for some higher power than the one granting a license to review the matter, and I suppose to revoke a license where granted as above referred to. Maine after all the years of prohibition, in its State platform the Republican party again reaffirms its adherence to the law, while they say has done so much for the State, and avows against any resubmission of the question to the people.

It could be wished that one or the other or both of the dominant political parties in their national platform could say a word in favor of a law which would be to the advantage of so rarity of its constituents, but we look in vain for any declaration, though organized labor and other elements with votes behind them are given great consideration. Well let us for the time be contented and happy that at least there is one party that will speak out and give us what we demand, and press on with the work, until such a time as it shall become the paramount issue in national affairs.

Yours for Prohibition
L.C. Andrews.[89]

Ironically, local option was meant to provide some stability on the issue of alcohol in Vermont by removing the decision at the state level and allowing the choice to be made at the local level. Unfortunately, stability never arrived, and local option became a heated yearly debate for many towns. The local shifts that occurred also created circumstances that led to an unfortunate gray area in terms of legality in many towns.

10
LIGHTNING STRIKES TWICE

The town of Bristol saw one of the most horrific events of Vermont's long period of prohibition. In 1914, the town had three drugstores. The Village Drug Store was owned by Dr. Don A. Bisbee. In Bristol, as in many towns in Vermont that were dry, alcohol was still available by a physician's prescription and could be obtained at the local drugstore. On the surface, the laws in Vermont created a rigid framework for the medicinal use of alcohol, but they also gave rise to strong and dangerous black and gray markets in the state.

Bisbee came to Vermont a few years after he completed his studies in medicine at the University of Michigan. In 1880, he purchased the Village Drug Store from Hiram Shattuck and pursued a career as a druggist rather than a physician, although he was never able to obtain a druggist's license with the state due to his colorful past. With a rap sheet that included numerous charges for illicit alcohol sale, for which he was repeatedly fined, and two counts of adultery that led to his serving a sentence of two and a half to three years in state prison in 1904, he was disqualified from obtaining his druggist's license. Somehow he was able to continue his operation and his sale of illicit alcohol, most likely with the assistance of local law enforcement—a common parasitic side effect of Vermont's prohibition law.

When Bisbee received his weekly delivery on Friday, October 29, 1914, included with it was a ten-gallon can marked "cologne spirits," for which he paid thirty dollars. It is important to note that "cologne spirits" fell under pharmaceutical and industrial use and were not deemed fit for human

consumption. The particular cologne spirit Bisbee received was from John L. Thompson, Sons & Co., from Troy, New York. Bisbee made the deadly assumption that his cologne spirit was nearly pure grain alcohol and bottled it in pint bottles, selling each pint at the pharmacy for sixty cents.[90]

The horrific consequences of Bisbee's actions became hauntingly clear very quickly. Over the next forty-eight hours, it was estimated that upward of eighty people consumed the poisonous alcohol. That Sunday, not more than forty-eight hours after Bisbee received the wood alcohol, the first three deaths were reported. The next day, seventy-two hours later, another nine died. The last to directly die from direct consumption was on November 14, over two weeks after consuming the poisonous alcohol. Bisbee's mistake led to thirteen deaths within a month; he was held accountable for them all, along with an unknown amount of pain and suffering endured by survivors. A few reports in professional pharmaceutical journals from the period put the number at fifteen, though the names of the victims were never published. Those who died all reported the classic symptoms of grain alcohol consumption. It started with blindness, intense pain, vomiting and loss of motor skills. The list of the dead also showed that the bottles of Bisbee's wood alcohol traveled quickly. Those who died from consuming Bisbee's bottles were Samuel King, Fred O'Bryan, Wallace Hanmer, Phila Tatro, Henry St. George, Patrick Welch, Cyrus Curry, L.L. James and Francis McBride, all from Bristol; Aldice Jackman from Lincoln; Ernest Duprey from New Haven; Edward Wakefield from Warren; and Willard Sargent from Huntington.[91]

There was an obvious and intense reaction to what was unfolding in Bristol. The devastation was felt in the town of roughly two thousand inhabitants. With emotions running high, threats were made to lynch Bisbee,[92] as well as to question town officials and law enforcement. With Bisbee's history of arrests and his reputation for being a known liquor seller, some folks in Bristol wanted the blame for the deaths to fall on those who had allowed his actions.

The Vermont professional pharmaceutical field was very quick to separate itself from Bisbee and condemn him for his actions. In a letter to the *Pharmaceutical Era Journal*, the head of Vermont's professional pharmaceutical group focused on pointing out that Bisbee's pharmaceutical license had been revoked when he was sentenced to prison for one of his previous infractions with the law. While Bisbee at one point was a registered pharmacist in Vermont, he was no longer licensed to practice well before the deaths in Bristol. The letter also noted that while due to archaic laws authorities were not able to shut him down, they were legally allowed to confiscate all signage

that would suggest Bisbee was a pharmacist. Bisbee was still able to call himself a druggist, which irked the pharmaceutical world.[93]

The court case that instantaneously ensued brought to light some important information that was often difficult to uncover during prohibition. During the course of his operation in Bristol, Bisbee admitted that he had been doing business with John L. Thompson, Sons & Co., of Troy, New York, for thirty years. By Bisbee's estimate, he had paid the firm around $100,000 for the supply of alcohol over that period. He admitted that on the last order, he made a 62 percent profit—which, if his numbers were accurate, would mean that Bisbee made around $70,000 in profit over the period of doing business with the Troy firm. This was a substantial amount of money and shows just how lucrative the illicit alcohol trade could be.

Before his death, Fred O'Bryan of Bristol stated that the liquor he had consumed was indeed from Bisbee's store. This was enough evidence for a warrant to be issued to search Bisbee's store; the search was conducted by Deputy Sherriff G.S. Farr and Constable G.W. Farr. They found stocks of both grain alcohol and the poisonous wood alcohol that was causing the deaths.[94] Bisbee was arrested, and while in custody in Middlebury, he made the statement that "they had confidence in me when they made the purchase. They died thinking that 'Doc' had made a mistake. This is terrible."[95]

Bisbee remained in jail until a December 11, 1914 grand jury inquest found reason to charge him with five counts of manslaughter. While Bisbee had clerks helping to operate his store, the clerks never faced trial or any other judicial proceedings. One clerk, Mark Hutchins, was initially charged in the death of Francis McBride of Bristol, but the charges appear to have been dropped since there are no court records or evidence of a trial or settlement. Considering the murky laws on prescribing alcohol, Hutchins may have been merely following Bisbee's orders.[96]

Bisbee's trial was slated to start on Monday, December 28, but due to chief judge Willard W. Miles missing a train from Burlington to Middlebury, the case was recessed until the next day. Attorney General Herbert G. Barber of Brattleboro and state's attorney Frank Tuttle of Vergennes opted to charge and try Bisbee for one count of manslaughter in the death of Cyrus Curry of Bristol. The manslaughter charge stemmed from what essentially amounted to death by poison (wood alcohol). While a total of thirteen deaths resulted from the wood alcohol, the prosecution focused on the death of Cyrus Curry. The *Middlebury Register* considered this case one of the most important in the last fifteen years, and it was a front-page headline every day for the first week of 1915.

After jury selection was made and the trial commenced, it was rather easy to see the prosecution's reason for going after only one count in the death of Cyrus Curry. Curry's suffering and death were well documented and witnessed. Dr. H.P. Williamson of Bristol treated Curry on November 1 for the effects of alcohol poisoning. The next time Williamson saw Curry was after he died. The prosecution called Curry's mother, Mrs. Mary Curry, to the witness stand; she explained that on November 2, after having seen Dr. Williamson the day before, her son started to fall ill and quickly deteriorated. One of the other witnesses for the prosecution was Dr. B.H. Stone, head pathologist at the University of Vermont Medical School, who on November 3 examined Curry's body. Dr. Stone attested based on his autopsy, in his opinion Curry had succumbed to wood alcohol poisoning. The defense's case was squarely based on the argument that it was not Bisbee's fault since he had placed an order for grain alcohol; rather, it was the Troy firm's error that had caused the deaths. After a couple days of witness testimony and proceedings, on Thursday evening Bisbee was found guilty. The following morning, he was sentenced by Chief Judge Miles to twelve to fifteen years of hard labor at Windsor Prison. The remaining four counts found by the grand jury were never prosecuted. At the time of his conviction, Bisbee was about sixty-three years old, though some papers put him at seventy, and age was most likely the reason further prosecution was never pursued. To put the sentence and Bisbee's age into perspective, varying statistics from state and local records estimated that the average life expectancy of a man in the United States in 1915 was around fifty-seven. A sentence of twelve to fifteen years' hard labor for a man of sixty-three was most likely thought of as a life sentence.

The next few years of Bisbee's imprisonment saw the launch of a civil suit against John L. Thompson, Sons & Co., for damages due to the shipment of grain alcohol that had started this horrific chapter in Addison County's history. After a lengthy civil suit, Bisbee won. The verdict appeared on the front page of the *Middlebury Register* under the headline: "Echoes of Wood Alcohol Case." Bisbee was awarded a total of $1,750 for damages incurred from the shipment of alcohol back in October 1914. One of the glaring omissions in the case was that the generic term "alcohol" was used, with no specific reference to wood or grain alcohol. Shortly after receiving the result of his civil suit, Bisbee proceeded with a petition to be pardoned by the governor of Vermont, Horace Graham. For one reason or another, Graham never made a ruling on the issue. The following year, however, a new governor was in office, and on May 22, 1919, Governor Percival

TREASURY DEPARTMENT

UNITED STATES INTERNAL REVENUE

Office of Director

DISTRICT OF VERMONT:

I, James E. Kennedy, Federal Prohibition Director, within and for said District, do hereby certify that the foregoing copy is a true and correct transcript of a Permit to receive transport & deliver Intoxicating Liquor issued to Bristol Railroad Company of Bristol, Vermont under the National Prohibition Act and Regulations issued thereunder.

IN TESTIMONY WHEREOF, I hereunto affix my seal and subscribe my name at Burlington in said District, this 27th day of June, A. D. 1931.

Federal Prohibition Director

Right: The state permit allowing the Bristol Railroad Company to transport alcohol for medicinal or industrial use during federal Prohibition. *Courtesy of Vermont State.*

Below: The federal permit issued to the Bristol Railroad Company. *Courtesy of the Vermont State Archives.*

PERMIT ISSUED UNDER THE NATIONAL PROHIBITION ACT

Serial No. Vt-C-12

TREASURY DEPARTMENT
UNITED STATES INTERNAL REVENUE

PERMIT ISSUED UNDER THE NATIONAL PROHIBITION ACT
AND REGULATIONS ISSUED THEREUNDER

OFFICE OF FEDERAL PROHIBITION COMMISSIONER.

WASHINGTON, D. C.

To Bristol Railroad Co.,

Bristol, Vermont

Application having been duly presented and approved, you are hereby authorized and permitted to Receive, Transport and Deliver intoxicating liquor for non-beverage purposes. The permittee will be held to a strict compliance with the regulations relative to the transportation of liquors.

Clement granted Bisbee a pardon after he had served nearly one-third of his sentence. Clement was heavily influenced by Bisbee's success in his civil suit; he placed the blame on John L. Thompson, Sons & Co., which had sold Bisbee the alcohol.

After his time in prison and the attention of the case, Bisbee lived in Rutland and then ultimately moved back to Bristol, where in the last couple years of his life he relied on town assistance for housing. He died on August 6, 1935.[97] This ended one of the darkest moments in Vermont's prohibition history.

FEDERAL PROHIBITION IN VERMONT

The onset of federal Prohibition marked another chapter in Vermont's relationship with alcohol. From the election of 1902, when Percival Clement was able to push the issue of prohibition to the forefront of the gubernatorial race and ultimately succeeded in getting prohibition lifted, there was still a substantial part of Vermont that wished to see complete prohibition remain in effect. One of the biggest changes that occurred with federal Prohibition in Vermont was that the issue was no longer just a state concern but now also a national one. Due to Vermont's border with Canada, federal Prohibition brought a darker chapter to the state. Smuggling became an industrial-scale operation, and Vermont saw its rural roads and beautiful countryside become sites of criminal mischief and violence.

It is important to separate prohibition in Vermont into two distinct periods. State prohibition, along with local option, which was essentially a second form of prohibition, was highly politicized in towns and allowed local populations to have some say. Federal Prohibition saw the emergence of gangs and crime syndicates from outside Vermont that were using the state for their own gains. While Vermont struggled with enforcing state prohibition to the point that towns such as Peacham, Middlebury and St. Johnsbury sent in petitions for stronger enforcement, it honestly never stood a chance at enforcing the law.

The onset of federal Prohibition in Vermont was an unfortunate situation. After multiple attempts to gain the governorship, Percival Clement was elected in 1918. This time, Clement had the full support of the state Republican Party, which helped him cruise to victory with a majority in the general election. Many had hoped that Clement's well-known stance against prohibition would lead to a full and complete repeal of local option,

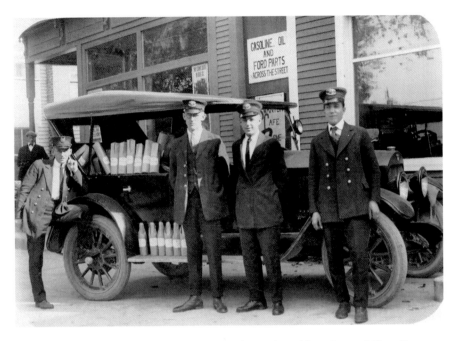

Vermont border patrolmen at the Swanton crossing posing with a seizure of Canadian whiskey. *Courtesy of the Vermont Historical Society.*

which for many communities was a continuation of the prohibitory policies of the 1853 Liquor Law. In towns that did vote to go wet, the restrictions of local option grossly limited to one or two the number of saloons permitted. Alcohol was once again sold in the state, but with the amount of restrictions in place through local option, prohibition might as well have been the law of the land. Each year around the time of town meeting day, advertisements from groups for and against prohibition flooded the newspapers. The biggest opposition to local option was the Anti-Saloon League of Vermont, which had both state and national support. Local option brought the battleground from Montpelier to each and every town in the state.

Once Clement was governor, his anti-prohibition views were the foundation of many of his policies. Unfortunately, what had once been an asset to his political rise more than a decade earlier would now be his Achilles heel. One of the views Clement forged from his fight to overturn the burden of local option was that the main force behind the temperance movement was women. In 1919, a bill giving women the right to vote passed the Vermont House and senate and was brought to Clement to sign. Clement vetoed the bill as unconstitutional, and there was not a proper majority to override his

veto. His reason for the veto was that the main goal behind women's suffrage was to reintroduce prohibition to Vermont. Despite Clement's actions, Vermont women gained the right to vote thanks to Tennessee, the last state needed to ratify the Nineteenth Amendment. Clement had the opportunity to be the deciding vote in the national referendum but opted to deflect the vote to the following legislative session.[98]

In what must have been the lowest point of his political career, Clement saw the onset of federal Prohibition. After Clement was elected and the state legislature session commenced in the fall of 1919, the federal Congress was able to override the veto of President Woodrow Wilson on October 28. The override led to the Eighteenth Amendment and the Volstead Act, named after judiciary chairman Andrew Volstead of Minnesota, and the amendment was referred to the states for ratification. Vermont delayed the vote as long as possible, but on January 29, 1919, it became the forty-fourth state to ratify the constitutional amendment.

While many thought Vermont's problems during the fifty-year period under the 1853 Liquor Law were convoluted and troublesome, the onset of federal Prohibition ushered in a far darker period. Overnight, alcohol was again illegal in the Green Mountain State, only this time it was illegal everywhere else in the United States, too. This put a focus on Vermont, primarily due to its shared border with Canada and its access to Canadian rye whiskey and beer.

Federal Prohibition was a profoundly different circumstance than state prohibition. To start, state prohibition was self-induced, and the remaining states in the Union remained wet most of the time. Albeit, there were short periods of state prohibition in other New England states, but alcohol was almost always available just across the borders. Vermonters who desired alcohol had to smuggle it back to Vermont through a vast expanse of land with dubious enforcement, as previously discussed. Aside from the rails, it was very difficult to enforce the law and prevent smuggling. Sales of liquor were a whole different circumstance in terms of enforcement. Federal Prohibition focused attention from Vermont's entire expansive border to a single northern stretch of roughly ninety miles. The significantly smaller border gave law enforcement a fighting chance to uphold the law. Lake Champlain became a battleground in the enforcement war.

With Vermont now in the same situation as other states in the country, the border with Canada attracted a new problem: organized crime. Under state prohibition, organized crime had existed only in larger towns, and even that was quite localized. The organized crime that did exist paled in

Above: A political cartoon depicting Americans traveling to Canada during federal Prohibition. *Courtesy of Scott Wheeler.*

Right: A pamphlet pressuring for heavier enforcement against the smuggling of liquor. *Courtesy of Scott Wheeler.*

THE CRIME
OF
Rum Running on the Vermont Border

MUST BE STOPPED

The constant smuggling of Scotch and Canadian whiskey into and through Vermont, is in violation of State and Federal law and a crime against our Constitution.

THE VERMONT ANTI-SALOON LEAGUE proposes to thoroughly investigate and expose this awful traffic of rum running and insist that the laws be enforced.

This program means much work and heavy expense but it can be done.

WILL YOU HELP?

comparison to what emerged during federal Prohibition. Large organized crime syndicates flocked to Vermont to set up transportation routes to the Boston, New York and Newport (Rhode Island) markets, where the thirst for liquor created huge paydays. Violence was never really a factor during state prohibition, but unfortunately it was quite a common headline during federal Prohibition.

Next was the technological jump. While Vermont did have the railroad during state prohibition, it was fairly easy—at least in theory—to enforce the law at railroad depots located near the borders. Federal Prohibition came after the automobile had been developed and better-quality roads created. This gave mobility to the masses, and the speed of movement had dramatically increased compared to the nineteenth century. A distance that might have taken hours or even a day to cross could now be covered in a fraction of that time. Automobiles could also have their suspensions increased and the frames altered to take much larger loads of alcohol. With the use of automobiles came the repair garages to maintain them. This created opportunity for gangs to set up a footprint in Vermont towns: "One such syndicate, headquartered in Barre, set up a repair garage in Richford ostensibly to offer its service to the public. In reality, it was a 'front' and a shop to keep the operation's cars in top condition for their runs from Montreal to New York and cities in southern New England, where the demand for good Canadian whiskey was also insatiable."[99] To give one an idea of how bad the situation of crime gangs and their fleets of cars became, the *Boston Evening Transcript*'s headline on July 29, 1931, read, "Vermont's Toughest Town Moves to Rid Itself of Gangsters."[100] The town to which the article referred was Lyndonville; federal Prohibition had caused it to be overrun with gangs and their rumrunning cars. Similar situations occurred in Richford and Newport due to their proximity to the border.

Boats were another tool that was utilized by bootleggers and smugglers. Just as automobiles were altered, boats, too, were changed to take on larger and heavier cargo but still escape the authorities. Officials had two lakes to patrol that shared the international boundary, and these bodies of water were in many ways far more difficult to patrol. Enforcement of federal Prohibition presented many of the same challenges faced during the state period, only this time speed was also an issue. There was essentially an arms race that occurred between smugglers and gangs and the officers who were trying to capture them. The boats and cars kept getting more powerful and faster and created quite a game of cat and mouse. In an oral history recorded by the

A photo of border patrolmen during federal Prohibition. *Courtesy of Scott Wheeler.*

Vermont Folklife Center, Earl Cheney of Newport relayed a tale involving Lake Memphremagog:

> *They'd come down the lake with loads of their stuff. We had a lot of local bootleggers. It was Prohibition and I know one fellow over here, lived on Hill Street* [Newport], *and he was an honest man and he sold it. And it was taken across the line. They'd come across with small boats, even rowboats. They'd take a load in a rowboat, fifteen to twenty bags of beer. They'd come down the lake with it and go right up the Clyde River, and he'd be waiting for them. They'd unload it up to his house and in back of his house he dug these big holes, and attached sod to a board and made a cover for the hole. You could walk right on it, and you wouldn't go down through the hole 'cause you didn't know where it was, just like grass out in the back of the house. And anybody would go there and get a couple quarts of beer a lot of times. I knew where he kept it, right out back. Always had a big dog around there. He'd bark if anybody would come near.[101]*

Over on Lake Champlain, similar tales were told. There are many records from both smugglers and police officials about the adventures on

the lake—so many tales that an entire standalone book could be written detailing the stories. Through the efforts of the Vermont Folklife Center and historian Scott Wheeler and his 2002 book *Rumrunners and Revenuers: Prohibition in Vermont*, as well as his continued work in the *Northland Journal*, many of the tales and oral histories were recorded before it was too late. One such oral history was that of Pete Hanlon of Burlington, a "retired bootlegger, mechanic, and raconteur":

> *I use to bring in* [to Burlington] *thirty-five, forty cases at a time. There was quick turnover with this beer. I use to buy it for $3.75* [a case], *and I'd bring it into Burlington and get one dollar a bottle. Then I went into the hard stuff—Jack, my brother, had connections. I used to buy twenty-eight dollars a case. I'd bring it to Burlington, and I'd get a hundred twenty dollars a case.*[102]

At the time of his last interview, Hanlon was 101. He was unable to give accounts of his exploits, but his 75-year-old daughter, Dorothy Minoli of Burlington, recounted the stories he had told her over the years. Hanlon was a longtime bartender at the old Hotel Vermont Tap Room and was well known around Burlington. His daughter told of how he smuggled alcohol down for the bar, as well as for private parties, though he personally did not drink. Days before the article was published, Hanlon passed away.

Aside from the bars, hotels and private parties in Burlington, another popular destination for smuggled alcohol was Charlotte. Often, the smuggled alcohol that was jettisoned across Lake Champlain ended up in the hands of the wealthy. According to one account, "much of the alcohol that landed in Charlotte…was destined for the wealthy families who lived on the so-called Gold Coast, the stretch of lakefront between the Charlotte ferry landing and Shelburne."[103] Smugglers' fast boats made enforcement difficult along the "Gold Coast."

Another difference between state and federal Prohibition was the proliferation of speakeasies, or hidden bars, as well as line houses, in addition to hotels and cafés that were openly breaking the law. It is unclear how many of these existed in the state, but based on news accounts from when proprietors were caught, there were quite a lot. Speakeasies could be hidden anywhere in any town. Living rooms, basements and kitchens all served as places where illegal bars were set up to sell illicit liquor. Vermont's unique geography also created situations where one's living room could be located in Canada while the rest of the home was in the United States. These

A postcard depicting the Canaan Line House spanning the international border. Note the placement of the American and Canadian flags. *Courtesy of Scott Wheeler.*

A photo of the interior of the Canaan Line House. *Courtesy of Scott Wheeler.*

were called line houses—homes that happened to span the international boundary. Utilizing the boundary to their advantage, people set up lucrative operations. One of the most successful line house characters was Lillian Miner, lovingly referred to as "Queen Lil," of Richford. A record of an arrest shows how difficult line houses were to stop:

> ### FEDERAL RAID MADE
> *Gallon of Liquor Seized at Line House Between Richford and Abercorn.*
>
> *The line house between Richford and Abercorn, Que., operated by Fred St. Onge, who is under arrest in Vermont on a charge of keeping intoxicating liquors for illegal purposes, seems to be the center of official attention at just this time.*
>
> *No sooner had the state authorities, working in conjunction with the Quebec officers, made their raid than the federal customs officers in Richford took a hand and conducted a raid which resulted in the seizing of about a gallon of alcoholic liquors.*
>
> *It is supposed that the raid was made to determine whether liquor was taken across the line without any duty being paid on it, and this probably will be the charge brought against St. Onge.*[104]

Many of the line houses were able to elude authorities and move the alcohol from one country to another, often minutes before a raid occurred.

Rumrunning and speakeasies in Vermont were not just limited to the shadows during federal Prohibition. In some cases, businessmen of Vermont launched ambitious construction projects around the state that also happened to be speakeasies in plain sight. One example was the proposal to construct the Verte-Montagne, a luxury resort built on the international boundary in Richford, Vermont.

The proposed hotel was to be a sprawling retreat with 250 rooms, a variety of dining rooms, lounges, a grand ballroom and many sporting venues. While this may seem like any other resort proposal, the location was of the utmost importance. What stands out in the prospectus for the Verte-Montagne was that, of the 950 acres that the hotel would occupy, "some 90 acres [were] under the flag of the British empire, and there, in a maple grove at 'the 19th hole' of the golf course, [would] arise an elaborate club house similar in architecture to the hotel."[105] The proposed clubhouse would have been a sizeable tavern and the focal point of the resort, allowing visitors to enjoy drinks without fear of arrest. With Richford's location on the international boundary with Canada and multiple transportation options due to railroads

The prospectus for the Verte-Montagne Hotel on the border, with a speakeasy to be constructed on the Canadian side. *Courtesy of the Vermont Historical Society.*

and auto travel, the location offered a perfect place for such a grand hotel to emerge. Unfortunately, the hotel never got enough investors to launch, and ultimately the taxpayers were left with the bill. Across Vermont's northern international border, many homes and other buildings were constructed before the international line was clearly established.

During the midst of federal Prohibition, President Herbert Hoover, in a letter to Senator W.H. Borah, dated February 23, 1928, on the Eighteenth Amendment, famously stated that "our country has deliberately undertaken a great social and economic experiment, noble in motive and far-reaching in purpose."[106] In Vermont's case, prohibition was, at best, a noble failure. Loosely enforced, the law created more issues than the problems it intended to solve. Prohibition in Vermont, in many ways, was an attempt to re-center society by the most aggressive method possible. In the face of widespread alcohol consumption, loss of productivity and deterioration of family life, prohibition was touted as the cure-all solution. While it resolved some issues, it raised even more questions. The black market that emerged in Vermont funneled money north of the border to Quebec and into neighboring states rather than keeping it the state.

Raids and seizures of alcohol in Vermont were a nearly daily occurrence, and the amount that was captured and the criminals caught were just a small fraction of what existed in the state. During federal Prohibition, however, laws and penalties were more severe. The case of E.G. Foss, accused of driving under the influence, heard in Lamoille County Court was compounded by the fact that Prohibition increased the penalty for intoxication. The jury found him guilty of "operating a motor vehicle over and upon the highway under the influence of intoxicating liquor." Foss was sentenced to six to twelve months of hard labor at the prison in Windsor.[107]

Rather than go through a year-by-year review of all the raids and arrests, a simple news roundup from a single day sums up the period of federal Prohibition in Vermont. The passage that follows was recorded in the *St. Albans Daily Messenger* on November 18, 1922:

News of State

Sheriff W.L. Fairbanks and Sheriff H.O. Dodge, of Springfield with Deputies Cleo Cox and C.J. Paul, of Woodstock, raided Charles Godfrey's farmhouse, five miles southwest of Woodstock, seizing a still and two or three gallons of moonshine. The liquor was found in several places about the house. Godfrey is 75 years old. At a hearing before Judge A.G. Whitham at South Royalton, he was held for trial in municipal court October 20, bail being fixed at $500 which was furnished.

The Union Station hotel, at the corner of Battery and Main St., in Burlington, was raided Thursday afternoon by prohibition agents and a quantity of liquor was located in a trunk which was in a bedroom of the hotel. James Poulous, proprietor of the house, and Peter Columbus, a waiter, were arrested and turned over to the police. The liquor was in half-pint bottles. Two of the federal officers were successful in purchasing some of the intoxicants and it is alleged that sales can be proven on both the men arrested. In case of a hotel where liquor is proven to be sold, the house may be closed for a year, under the abatement section of the Volstead act. In this case the hotel would be declared a public nuisance, as was the Paradise hotel in New York recently.

Raid Grocery Store.

General agents of the federal prohibition department conducted a raid upon the grocery store of John D. Brandon, of Burlington, which is just across the railroad track from the depot in Winooski Tuesday afternoon and took possession there of 12 bottles of Scotch whiskey and six and a half gallons of alcohol. Mr. Brandon and Joseph F. Christino who was in the store at the time the raid was made, and claimed to be the manager of the store, were placed in the county jail, charged with possessing and selling liquor. The search was made on a warrant issued by Commissioner C.D. Watson, of St. Albans. Brandon is said to be an old offender in the liquor business. The general agents who made the raid are the same who recently conducted the raid on the Union Station hotel in that city. Their work is being done under the supervision of John O. Appleby, division prohibition chief of the second division, comprising New York and New Jersey.

Make Big Haul at Newport.

Hearings before United States Commissioner Walter H. Cleary, in St. Johnsbury Monday disclosed the intense vigilance that is being exercised by

the prohibition forces at Newport. As a result three Massachusetts men are under heavy bail for alleged violations of the Volstead act.

One hundred and seventeen quarts of first class whiskey, a man, a Buick car comprised Sunday early morning toll [sic] when federal officers, who have been on a still hunt hereabouts for several days, drew in their net.

Walter D. Perkins, of Turner's Falls was apprehended in Barton near the high bridge just before coming to Barton golf links, early Sunday morning. His Buick car held a rich prize being loaded with choice brands of whiskey which would have netted its owner several hundred dollars had he been able to evade the minions of the law.

Perkins was lodged in Orleans county jail and at a hearing before Commissioner Cleary Monday, he was placed under bonds of $1,500 for his appearance at United States federal court at Brattleboro in December. At a late hour last evening Mr. Perkins had not secured bail.

At Richford, Eric Johnson and Helan Rogers, driving a "Pierce Arrow" had the tidy little supply of 36 bottles. They were taken into custody Sunday, and brought to Newport where they were charged with violation of the National prohibition act at a hearing before Commissioner Cleary Johnson who hails from Waltham, gave his address as 87 Fish street. He was placed under $200 bonds, which he was able to secure after communicating with his home town. Rogers was given the same amount of bail which was furnished by Earle Brown.

The officers were very much on the alert Sunday and were station[ed] on the main roads from Canada going south. Many cars were challenged including those innocent of any violations of the liquor law.[108]

No matter the year or the week during federal Prohibition, such news clips were common. The size of the articles noticeably decreased as federal Prohibition dragged onward through the Roaring Twenties.

Out of federal Prohibition in Vermont emerged a group that was in clear defiance of the law. Composed of like-minded people who wished to pursue the art of brewing and carry on the treasured recipes, the group met in private and shared recipes and tales of brewing. During federal Prohibition, one could file a declaration for producing wine for home consumption only, limited two hundred gallons. By chance, the group published the proceedings of one of its meetings, documenting the lectures and histories presented. The opening address was as follows:

NOTICE OF INTENTION TO PRODUCE WINE FOR FAMILY USE
OF THE PRODUCER THEREOF NOT IN EXCESS OF TWO HUNDRED
GALLONS AND NOT FOR SALE OR TO BE OTHERWISE REMOVED
OR CONSUMED.

To the Collector of Internal Revenue,
Burlington, Vermont.

Sir:

I, Giuseppe Arioli of /83 Barre Street, Montpelier,
in the County of Washington and State of Vermont, hereby
give notice that on or about December 14th, A.D.1922, I
intend to commence producing wine solely for my family
use and not for sale or to be otherwise removed or consumed
and that I do not intent to produce more than two hundred
gallons of wine during the present vintage season.
I further state that if I produce or have on hand at
any time, more than two hundred gallons of wine during the
present vintage season, I will give timely notice thereof
on Form 698, execute bond form 699, or execute bond and de-
posit collateral as provided in T. D. 3765 and in all other
respects comply with the requirements of that Treasury De-
cision and all other regulations relating to the production
and sale of wines.
Dated at Montpelier, in the County of Washington and State
of Vermont, this 9th day of December, A. D. 1922.

Giuseppe Arioli

I, _Webber_ Deputy Collector of Internal
Revenue hereby certify that the foregoing is a true and
correct copy of the original thereof, by me this day ex-
amined and herewith compared.
Dated at Montpelier, this //th day of December, A.
D. 1923.

W. E. K.

Deputy Collector Internal Revenue
District of Vermont.

A letter declaring the production of wine strictly for home use in Barre during federal
Prohibition. There is a disproportionate amount of these from Barre compared to other
cities. *Courtesy of the Vermont State Archives.*

*The gathering and printing of the several addresses delivered before the
Annual, Special, and Monthly Meetings of* The Company, *mark a new
departure in the policy of this Society. The move was instituted by a formal
vote of the members assembled at the last Annual Meeting, holden October
first, 1931, in order that members, particularly new members, might have
a permanent record of the mass of material which otherwise would not be
preserved. I have the honor to present these* Proceedings, *hoping they may
be the first in a long series.*

NOTICE OF INTENTION TO PRODUCE WINE FOR
FAMILY USE OF THE PRODUCER THEREOF NOT IN
EXCESS OF TWO HUNDRED GALLONS AND NOT FOR
SALE OR TO BE OTHERWISE REMOVED OR CONSUMED.

To the Collector of Internal Revenue,
Burlington, Vermont.

Sir:

I, Rachael Colombo of 236 Barre Street, Montpelier
in the county of Washington and State of Vermont, hereby
give notice that on or about November 25, 1922, I intend to
commence producing wine solely for my family use and not
for sale or to be otherwise removed or consumed and that I
do not intend to produce more than 200 gallons of wine furing
the present vintage season.

I further state that if I produce or have on hand
at any time more than 200 gallons of wine during the present
vintage season, I will give timely notice thereof on Form
698, execute bond Form 699, or execute bond and deposit col-
lateral as provided in T.D. 3765, and in all other respects
comply with the requirements of that Treasury Decision and
all other regulations relating to the production and sale of
wines.

Dated at Montpelier, in the County of Washington
and State of Vermont, this 15th day of November, A.D.1922.

A second letter from Barre declaring the production of wine for home use.
Women were often the winemakers, with their names most often appearing on
the declaration letters. *Courtesy of the Vermont State Archives.*

*We were originally drawn together by one great compelling thirst in
common. This is plain. But there was more. Up here in Vermont, where* The
Company *started, a corner of the land once noted for its independence,
we still hold to a vestige of that quality so rare in the modern world. I
refer, of course, to a love of liberty. We Vermonters used (when we were
a separate sovereignty, free from the shackles of the Crown and likewise
from those of the unorganized colonies) to do as the spirit moved us. We*

hewed our way through the forests; we built outposts of civilization; we chastised the Yorkers who wanted our land...The spirit, we feel, has coursed down through the blood of generations and we are proud to love and honor the virtues of independence and liberty. Out of this spirit was born The Company of Amateur Brewers. *When the time came to take matters into our own hands; when we knew there was not at hand the satisfaction of our mutual thirst, we took to improving the situation. We took to getting the things we wanted. This was the origin of* The Company.

Eleven dour years have passed since the advent of our country's noble prohibitory regulations. During this doleful decade, the art of brewing has changed...in fact it has progressed in an entirely opposite direction. It has witnessed from the beginning a movement from the hands of private to those of commercial brewers, and now it has come back into the confines of the home. Everybody knows something of that horrible pandemic—the industrial revolution—that leapt upon us in the nineteenth century. That calamity put a stop to many pleasant factors of a not too unhappy existence. Definitely, and as one was beginning to think permanently, this universal upheaval in ways of living and working, checked the growth of the craft spirit among men and, in fact, snuffed out entirely the pleasant art of domestic manufacture.[109]

Woven into their hobby was Vermont wit and passion, and the record the group left was one of the most important in carrying on the knowledge of brewing through the difficult period of federal Prohibition. This record may be the only surviving record of recipes and the brewing tradition in Vermont. The publication of this work was a fitting nail in the coffin to federal Prohibition.

After the repeal of the Eighteenth Amendment in 1932, Vermont was finally able to close the door on a very long and difficult period. Prohibition had become so interwoven in the state's history that generations grew up under some form of prohibition or local option. It is difficult to look back at the eighty-year period from the 1853 Liquor Law to the repeal of the Volstead Act and gauge the economic impact on Vermont. The scarring from prohibition was lasting, though; it would take an additional fifty years for breweries and distilleries to recommence operations. When they did start operating again, they had to forge their own way since prohibition had effectively prevented any knowledge from being passed down. Thankfully, the state has been able to shake off the shackles of prohibition and create a vibrant artisan alcohol industry, finally bringing revenue back to the state.

11

LONG LIVE THE QUEEN

Vermont didn't have a national figure at the forefront of the temperance and prohibition movements like Carrie A. Nation, the hatchet-wielding crusader, but it had something of the opposite in the legend of Catherine Driscoll/Dillon of St. Albans. She was another woman who seized the opportunity to make a fortune at the expense of local officials and police.

Lillian Miner, later known as "Queen Lil," emerged as one of the more infamous characters in Vermont's long battle with prohibition and temperance. Miner was born in 1866 in Richford, Vermont, a town that shared a border with Canada. It is important to point out that just after the Civil War, Vermont saw many churches constructed and a flow of parishioners returning to fill them. Miner grew up near the peak of the Third Great Awakening, surrounded by both religious and temperance crusaders. She ultimately married A.G. Shipley, a man who was known for, among other things, robbery and theft. After traveling the country staging medical shows with Shipley, Miner settled down in Boston, where she worked as a madam in a brothel. The brothel was the Faneuil Follies, regarded as the finest and most expensive in the city. Before she could be arrested, she made her way back to Richford.[110] It was back home in Richford where Miner became "Queen Lil."

In the later part of the nineteenth century, the United States government put a ban on new construction spanning the international boundary in an attempt to prevent territorial disputes. In 1911, however, Queen Lil purchased a plot of land in East Richford with the ruins of a former hotel that

had burned to the ground; the land also happened to span the international boundary. After a court battle shortly after the purchase focused on her use of the property, Queen Lil argued and won the case on the grounds that she was not constructing a new building but was remodeling an old building. It also probably helped that she hired a high-profile Boston lawyer to argue her case.

The line house that was constructed—or rather, remodeled—was a three-story building within a stone's throw of the railroad. Known as the "Palace of Sin"[111]—or more commonly as "Queen's Place"—the first floor held a bar, and there were "private" entertainment rooms on the upper floors with girls from Boston and Montreal operating them. The private rooms "were all of a color, décor, and furnishings alike, blue or red, giving an exotic aura of a time out of time."[112] Somehow, Queen Lil managed to build a lucrative hotel and business based on alcohol, prostitution and other activities—in plain sight and nearly untouchable. With her larger-than-life personality and sharp wits—not to mention packing a pistol—Queen Lil was an unstoppable force. When the authorities interrupted her liquor deliveries, she had a special pipe installed underground to bring in the liquor and simply bottled at the hotel.[113]

Being well connected in the area, Queen Lil managed to have the train, as well as taxis, stop right at her door, bringing in customers. Her hotel attracted a wide variety of visitors and clientele from the region. By all accounts, Queen Lil ran the establishment very tightly and demanded a lot of respect in the area, leading to favorable times for her and anyone who worked for her.[114] For a decade, Queen Lil managed to avoid any serious conflict with the law. Through her vast contacts, she always seemed to know well in advance of impending threats from either the American or Canadian authorities and would simply have her booze moved to the Canadian side of her property (where it was legal) and the girls operating on the upper floors moved to the opposite side of whichever authority was raiding. She was finally caught when Canadian and American authorities conducted a joint raid on her establishment. During the course of the raid, five "couples" were discovered in the upper floors of her establishment, ranging in states of dress from barely clothed to fully unrobed. After more than a decade in operation, Queen Lil was charged with keeping a disorderly house, to which she pleaded guilty and paid the resulting fine of a mere $150—nothing more than a small bump in the road.

Queen Lil's lucrative though illicit business created substantial profits that were put into her second husband, Levi Fleury's, three adjacent farms. With

her increasing age and competition from hotels in Montreal and Boston and everywhere in between, Queen Lil Fleury finally retired to the farms she and her husband owned in 1933 and became known as "Queen of the Hills."[115] Lillian "Queen Lil" Fluery passed away in 1941; up until her death, she was known to travel into town with regal flair. With her passing went one of the most colorful characters in the state's history of prohibition.

The history of prohibition in Vermont has faded from memory, and most who lived during that period have been lost. It is important to look back at this lengthy chapter of the state's history and see not just the effects but also the circumstances that surrounded this very heated topic. Originally created as a reaction to what was clearly a problem with alcohol, the resulting laws helped shape and control Vermont's political history. What is clear as we look back today is that Prohibition and local option changed the social culture in the state. Thankfully, Vermont has moved forward, and rather than continuing to fight the production of alcohol, the state has embraced it, leading to a new and brighter chapter.

COCKTAIL RECIPES

It's just like finance. Whisky's wealth and cocktail's currency. If you can expand your currency without any increase to your wealth and do no harm, why can't you inflate this cocktail up to a hogshead full, and let all them bummers out in the street have a good square nip?[116]

Writing a cocktail section was never really my intention for this project. My thinking was to document what happened and who was involved. A question that started to form throughout this project—whether in researching people like Catherine Dillon and Queen Lil or uncovering the tales of smugglers and their actions—was what were they smuggling, serving and drinking during Prohibition? This thought organically developed into the idea of doing an appendix. After talking with many brewing, distilling and bar folks around the state, the idea morphed into doing a dedicated section on what Vermonters were drinking and mixing, then and now.

When looking at the late nineteenth and early twentieth centuries in terms of drinks, it becomes clear that what we know about beverages today is far removed from that period. Although Vermont was gripped by prohibition, many recipes or references to cocktails were republished in the pages of newspapers. Depending on the decade, different cocktails were in vogue. The Brandy Smash appears in passing reference during the middle of the eighteenth century and was one of the most common cocktails in the country when Vermont prohibition started. In an 1875 article in the *Middlebury Register*, the Whiskey Cocktail, more commonly known today as the Old-

Fashioned, appears. In this case, "the bar keeper was compounding the liquor [whiskey], syrup, bitters, ice, and water, in due proportion."[117] Other cocktails, from punches to gin concoctions, dot the publications toward the turn of the nineteenth century.

The core of these cocktails—the spirits—have also changed. A great example of this was the 2010 discovery of a 170-year-old shipwreck in the Baltic Sea that contained around 170 intact bottles of champagne from noted French champagne houses. The chemical analysis of these bottles showed that the alcohol by volume (ABV, our modern method of calculating alcohol) was in the range of 9.0 percent, with some bottles having sugar levels up to 150 milligrams. Today's champagnes, many from the same houses as the shipwreck bottles, average an ABV of around 12.3 percent and sugar levels of 0 to 50 milligrams.[118] The higher-range sugar levels in today's champagne are considered demi-sec or sec (semi-sweet to sweet). The next time you raise a glass of your favorite champagne, think about how times have changed.

Spirits were no different. During the course of this book, the two most common whiskeys referred to were Canadian and Scotch. Bourbon was around but not as common in Vermont, according to the records of what was seized. Geographic and climatic differences essentially dictated what was consumed in the state. In the case of Canadian whiskey, the core grain used in the distilling process was rye, while corn is the main ingredient in Kentucky Bourbon. Rye whiskey has more notes of spice and clove than the traditional whiskeys consumed in modern times, which use corn, or in some cases wheat, giving them a much smoother feel. Canadian whiskeys during the late nineteenth century tended to vary in aging. While modern times dictate minimum aging for whiskeys, historically this was not the case. Different cocktail guides—starting with the now immortal Jerry Thomas, a noted barman of the mid- to late nineteenth century who published the landmark publication *How to Mix Drinks, or The Bon-Vivant's Companion*—noted different whiskeys from white, or clear, to aged. While today's marketplace has seen resurgence in white whiskey under the popular shelf names of moonshine, white dog or white whiskey, it had a different set of names in Vermont during Prohibition. While white whiskey was a common reference, newspapers documented seizures by police of illicit booze with spirited names such as "Panther's Breath" or "Morning Dew."

Whiskey was not the only spirit to differ drastically from Prohibition times to today. The technological changes of the distilling industry, specifically the design and efficiency of distillation stills, have changed the taste of many of the spirits we consume. In the case of gin, sweetness was a factor, as was

the fact that all the gin produced during Prohibition would end up in oak barrels, coloring and flavoring the spirit. Ryan Christiansen, president and head distiller at Caledonia Spirits in Greensboro, Vermont, explained the changes in gin:

> *Old Tom Gin was a popular style in eighteenth-century England, before the introduction of the column still. With only simple pot stills, the impurities of the gin were difficult to remove by process of distillation, therefore leaving distillers with significant quantities of undesirable gin. In order to make the gin palatable, distillers would add sugar to soften the harsh edge and disguise the impurity of the gin. We've had a lot of fun taking these old stories and applying them to our products. Thanks to the invention of the column still, our modern-day adaptations to the Old Tom style stray from tradition and use quality products we can source from our region. Instead of sugar, we use raw honey to soften our Barr Hill Gin, which provides a full body and a touch of sweet to the spirit that pairs well with the piney botanicals. We also make a barrel-aged gin, Tom Cat Gin, which is similar but aged in oak for about half a year. Telling these stories with regional and modern adaptations to the recipe has been a focus of our distillery and has unveiled some remarkable flavors.*

In the marketplace today, Old Tom Gin is making a comeback, harkening back to the historical style that was consumed. The closest cousin to the flavors one would have tasted in these historic gins is Genever, commonplace in the Netherlands. An advertisement from 1809 notes:

> *The Subscriber will pay Cash for RYE delivered at his distillery in Guliford—where will be kept constantly for sale, by Pipe, Barrel, &c. GIN of very superior quality, in flavour and sweetness scarcely distinguishable from best imported Geneva—and of indisputable proof.*[119]

In today's marketplace, we are more familiar with the dry and clean-tasting gins that have developed from technological advancement.

Often, when we look at Prohibition-era cocktails, we think of colorful drinks that utilized citrus, fruits and syrups. The reason for using such additions was not necessarily to create a colorful beverage but to mask the harsh taste of the liquors that were used. While smuggling and bootlegging was rampant all over the Northeast, the available liquor was often young and raw in flavor. The sweet additions covered this rawness,

making a pleasing cocktail and at the same time increasing the volume of the drink.

The last aspect of Prohibition drinking was the art of making a cocktail. Books published in the United States and London in the 1880s and 1890s touted the importance and showmanship of mixing and presenting a cocktail. Proper glassware selection paired with placement of the garnish are details that were seemingly lost until writers like Gary "Gaz" Reagan and Ted "Dr. Cocktail" Haigh brought attention back to them. Through their efforts, as well as the efforts of many others over the last two decades, historic cocktails have made a resurgence for a new generation to enjoy. In Vermont, restaurants and taverns like the Three Penny Taproom in Montpelier, Prohibition Pig in Waterbury, Edson Hill in Stowe, the Farmhouse Taproom in Burlington, Guild Tavern in South Burlington and the Mule Bar in Winooski have all been creating craft cocktails, with many based on or inspired by Prohibition drinks.

The following recipes are a selection of cocktails, both old and new, that were served during Prohibition or inspired by the period. Many books have been published detailing at great length how to make cocktails, and this work is by no means meant to be a cocktail book. This is merely meant to pay homage to a past that we will never forget.

THE RECIPES

The first few cocktails are selected recipes from Jerry Thomas's 1862 *How to Mix Drinks, or The Bon-Vivant's Companion*. These recipes were considered the cutting edge of cocktails when they were printed a century and a half ago. While some have fallen out of favor, including them here is my way of paying respect. Jerry Thomas's book was the most complete work on the subject of cocktails when it was printed. It predates the creation of the Manhattan cocktail by a decade or so.

BRANDY SMASH

½ tablespoon of white sugar
1 tablespoon of water
1 wineglass of brandy

Fill two-thirds full of shaved ice, use two sprigs of mint, the same as a Mint Julep. Lay two small pieces of orange on top and ornament with berries in season

WHISKEY COCKTAIL
(SIMILAR TO MODERN OLD-FASHIONED)

3 or 4 dashes of gum syrup
2 dashes bitters (Bogart's)
1 wineglass of whiskey and a piece of lemon peel

Fill one-third full of fine ice; shake and strain into a fancy red wineglass

BRANDY COCKTAIL (USE A SMALL BAR GLASS)

3 or 4 dashes of gum syrup
2 dashes bitters (Bogart's)
1 wineglass of brandy
1 or 2 dashes of Curacao

Squeeze lemon Peel; fill one-third full of ice and stir with a spoon

FANCY BRANDY COCKTAIL
(USE A SMALL BAR GLASS)

This drink is made the same as the Brandy Cocktail, except that it is strained in a fancy wineglass, a piece of lemon peel is thrown on top and the edge of the glass is moistened with lemon.

BRANDY CRUSTA (USE A SMALL BAR GLASS)

This drink is made the same as a Fancy Brandy Cocktail, with a little lemon juice and a small lump of ice added. First, mix the ingredients in a small tumbler, and then take a fancy red wineglass, rub a sliced lemon around the rim of the same and dip it in pulverized white sugar so that the sugar will adhere to the edge of the glass. Pare half a lemon the same way you would an apple (all in one piece) so that the paring will fit into the wineglass and strain the Crusta from the tumbler into it. Then smile.

———◆———

It's like the cocktails you know? Every man drinks them, but every man can't mix them. If they could, there would be no bar keeps.[120]

The effects of Prohibition on Vermont were long-lasting. Distilleries, wineries and breweries took a half century to reemerge. But today, the artisan beer, wine and spirits produced in the state are gaining international renown. With many operations still in their infancy, the artisan products that are being produced will only get better. Below are a few recipes from some of the top bartenders in the state doing the spirit of Jerry Thomas proud.

THE IRON BRIDGE BY EHREN HILL, THREE PENNY TAPROOM
Inspired by drinking many Hanky Panky cocktails

2 ounces Barr Hill Gin or Barr Hill Tom Cat (if you're like me and enjoy
* a barrel-aged gin)*
½ ounce Dubonet Rouge
¼ ounce Fernet Branca
¼ ounce Martinez Lacuesta Vermut Rojo
Dash of orange bitters

Stir with ice, serve over ice in a rocks glass. I get many requests for this to be served straight up as well, but my favorite is to sip it from a larger rocks glass with a single cube.

No matter how it gets into your hand, express some lemon oil from a peel over the top and garnish with a Luxardo Marasca cherry.

The Iron Bridge. *Courtesy of Ehren Hill.*

BERSERKER BY SEAN MCKENZIE, GUILD TAVERN
Bracingly complex and a perfect aperitif

1½ ounces Linie Aquavit
¾ ounce honey syrup
¾ ounce fresh grapefruit juice
¼ ounce Fernet Branca
2 sprigs fresh dill
2 dashes Bittermen's Boston Bittahs

Shake and double strain into a chilled coupe glass.

The Berserker. *Courtesy of Sean McKenzie.*

DORIAN'S SLIPPERS BY JEFF S. BAKER II
Dry, floral and sophisticated—a drink I'd love to share with Oscar Wilde

2 ounces Smugglers' Notch "Blend No. 802" Gin
¾ ounce ruby red grapefruit juice
¼ ounce honey syrup*
3 dashes Scrappy's Lavender Bitters
6 black peppercorns (whole)

Tools: Shaker, fine mesh strainer, Hawthorne strainer
Glassware: Coupe

Shake all of the ingredients and double-strain** into a chilled coupe. Express the oils from an orange peel over the surface and rest it in the glass.
*To make honey syrup, mix local honey with warm water (1:1) until dissolved, then chill.
**Double-straining removes extra ice fragments that will water down your drink.

JEFF S. BAKER II is a craft beer writer and philosopher living in Vermont. Follow him on Twitter at @aPhilosophyOf.

Dorian's Slipper. *Courtesy of Jeff S. Baker II.*

MONTPELIER MULE BY EHREN HILL, THREE PENNY TAPROOM

1½ ounces Green Mountain Lemon Vodka
½ ounce New Deal Distillery Ginger Liqueur
½ ounce fresh lemon juice
1¼ ounces cranberry juice
1¼ ounces ginger beer

Dry shake everything except ginger beer. Add ginger beer, then pour over rocks into a Collins glass or copper mug. Garnish with half a lemon wheel.

THE BITTER BREEZE BY MATT FARKAS, MULE BAR

1¾ ounces Barr Hill Gin
¾ ounce Campari
½ ounce Luxardo Marschino liquor
¼ fresh lime
2 dashes Orange Bitters
Fresh thyme sprig for garnish

Combine ingredients. Tart, bitter and very floral. The thyme adds some grassy nostalgia.

VERMONT SAZERAC BY JAKE JAMIESON, THREE PENNY TAPROOM

1 bar spoon (about ¼ ounce) maple simple syrup (1:1 maple syrup and water)
3 dashes Peychaud's bitters
1 dash Urban Moonshine Organic Maple Digestive Bitters (if unavailable, substitute Angostura)
2 ounces Bulleit Rye
Lemon peel
Absinthe (or Pernod) for rinsing the serving glass

Vermont Sazerac. *Courtesy of the author.*

Fill an Old-Fashioned glass with ice and water and set aside to chill. Once cold, drain ice water and rinse with absinthe.

Combine ingredients in a mixing glass or tin, fill with ice and stir contents until well chilled. Strain into absinthe-rinsed Old-Fashioned glass. Twist lemon peel over drink and rub it on the rim of the glass, then discard peel.

PERFECT MARTINEZ BY MATT FARKAS, MULE BAR

1½ ounces Tom Cat barrel-aged gin
½ ounce sweet vermouth
½ ounce dry vermouth
Bar spoon of Maraschino
2 dashes Urban Moonshine orange bitters

Stir with ice. Strain into a Martini glass and garnish with a lime twist.

Perfect Martinez. *Courtesy of the author.*

CORPSE REVIVER 2.5 (BLACKBERRY DROP REMIX) BY DON HORRIGAN, EDSON HILL

How about a Sumptuous Reviver? Traditionally, a morning elixir, the Corpse Reviver 1 and 2 was an apothecary pick-me-up for those who may have imbibed a bit too much the night before. The florals of Barr Hill's Raw Honey Gin and Lillet, the tartness of the fresh lemon, the sweetness of the French orange liqueur, the refreshing anise aromatics all play delightfully with the woodsy, Sumptuous Blackberry finish. See, you are feeling better already.

1½ ounces Caledonia Spirits Barr Hill Gin
¾ ounce Cointreau
¾ ounce Lillet 1872 Blanc
¾ ounce Fresh Meyer Lemon Juice
2 dashes Tenneyson Absinthe Royale
¼ ounce Sumptuous Syrups BlackBerry

Rinse chilled cocktail glass with absinthe. In mixing glass, combine gin, Cointreau, Lillet and lemon juice with ice. Stir. Strain into absinthe-rinsed cocktail glass. Layer Sumptuous Blackberry Syrup into bottom of glass. Add a lemon peel garnish.

Cheers!

NOTES

INTRODUCTION

1. Annie Turner Wittenmyer, *History of the Woman's Temperance Crusade* (Philadelphia: Christian Woman, 1878), 569.
2. *Washingtonian (Windsor, VT)*, July 27, 1812, 3.

CHAPTER 1

3. Vermont State Archives.
4. *The Laws of the State of Vermont*, vol. 2 (Randolph, VT: Sereno Wright, 1808), 4.
5. *Reporter (Brattleboro, VT)*, November 4, 1809, 1.
6. *(Bennington) Vermont Gazette*, September 24, 1804, 1.
7. *(Middlebury) Vermont Mirror*, November 22, 1813, 3.
8. *Vermont Sentinel*, March 14, 1803.
9. *Reporter*, March 18, 1811, 3.
10. *Weekly Wanderer (Randoph, VT)*, n.d., 4.
11. *Middlebury Mercury*, April 12, 1809, 3.
12. *Federal Galaxy*, "Directions for Making Ale and Strong Beer," December 12, 1797, 4.
13. *Vermont Gazetteer*, November 9, 1824, 3.

CHAPTER 2

14. Corin Hirsh, *Forgotten Drinks of Colonial New England* (Charleston, SC: The History Press, 2014), 11.

15. Frederick Wells, *History of Newbury* (St. Johnsbury, VT: Caledonian Company, 1902), 255.

16. *Burlington Weekly Free Press*, March 24, 1831.

17. Abby Maria Hemenway, *Vermont Historical Gazetteer*, vol. 5, *The Towns of Windham County* (Brandon, VT: Mrs. Carrie E.H. Page, 1891), 649.

18. Ibid.

19. Kurt Staudter and Adam Krakowski, *Vermont Beer: History of a Brewing Revolution* (Charleston, SC: The History Press, 2014).

20. *Middlebury Mercury*, February 6, 1805, 3.

21. Henry Swan Dana, *History of Woodstock, Vermont* (Cambridge, MA: Houghton, Mifflin and Company/Riverside Press, 1889), 186.

22. Ibid.

23. *North Star (Danville, VT)*, June 9, 1807, 3.

24. Vermont State Archives, A121-00001, Temperance Memorial 1-16 Hartford.

25. Ibid., Temperance Memorial 1-18 Middlebury.

26. Ibid., Temperance Memorial 1-24 Rochester.

CHAPTER 3

27. https://www.sec.state.vt.us/media/59772/1847.pdf (accessed March 14, 2014).

28. *St. Albans Daily Messenger*, February 3, 1903, 4.

29. Ibid.

30. Ibid.

31. Ibid.

32. Ibid.

33. https://www.vermont-archives.org/govhistory/Referendum/pdf/1853.pdf (accessed February 11, 2014).

34. William Shaw, *The General Statutes of the State of Vermont (Passed 9, 1862)* (Cambridge, MA: State of Vermont/Riverside Press, 1962), 588–94.

35. *Reporter*, September 30, 1809, 4.

36. *(Middlebury) Vermont Watchman and State Journal*, February 3, 1853, 2.

37. www.sec.state.vt.us/media/57293/1853.pdf.

38. Ibid.

39. J. Brockway, *The Resolution Adopted by the State Temperance Convention at Northfield, VT: "It's Crudity and Absurdity or the Old Theory of Government"— "Protect the Good and Suppress the Evil vs. the New. To Be Rid of the Evil Destroy the Good"* (Northfield, VT, 1858).

40. Ibid.

Chapter 4

41. *Burlington Free Press,* January 11, 1872.

42. *Rutland County (VT) Herald,* December 29, 1854; *Chronicling America: Historic American Newspapers,* n.d., Library of Congress.

43. *Burlington Free Press,* April 6, 1855; *Chronicling America.*

44. Ibid.

45. https://www.sec.state.vt.us/archives-records/state-archives/exhibits/vermont-court-records/vermonts-prohibition-era.aspx.

46. Ibid.

47. *Burlington Free Press,* January 11, 1872.

48. Ibid

49. https://www.sec.state.vt.us/archives-records/state-archives/exhibits/vermont-court-records/vermonts-prohibition-era.aspx.

50. Ibid.

51. *Burlington Free Press,* January 11, 1872.

52. *St. Albans Daily Messenger,* February 17, 1872, 3.

Chapter 5

53. *Vermont Watchman,* March 7, 1894.

54. *Bennington Banner,* April 27, 1894.

Chapter 6

55. *Rutland Daily Globe,* May 29, 1876, image 2.

56. Staudter and Krakowski, *Vermont Beer.*

57. *Rutland Daily Globe,* June 21, 1876, 2.

58. Ibid., June 5, 1876, 3.

59. Ibid., August 7, 1876, 3.

CHAPTER 7

60. Vermont State Archives, Caledonia Court Records, Box 39, Folder 25, Misc. Jail Report of Grand Jurors, June 1854.

61. Ibid., Box 62, Folder 45, #98, June 1894.

62. www.sec.state.vt.us/archives-records/exhibits/vermont-court-records/vermont-prohibition-era.aspx.

63. *St. Albans Daily Messenger*, January 7, 1870, 3.

64. Ibid., February 27, 1874.

65. Ibid., May 14, 1875.

66. Ibid., August 21, 1876.

67. www.sec.state.vt.us/archives-records/exhibits/vermont-court-records/vermont-prohibition-era.aspx.

68. library.uvm.edu/vtnp/?p=1292#more-1292 (accessed August 8, 2015).

69. Emma Goldman, *Living My Life*, vol. 1 (Dover, NY, 1970 reprint), 238–39.

CHAPTER 8

70. Unpublished manuscript in author's collection.

71. Ibid.

72. Mason Green, *Nineteen-Two in Vermont: The Fight for Local Option Ten Years After* (Rutland, VT: Marble City Press, n.d.), 16.

73. Ibid., 30.

74. Vermont State Archives, Caledonia Court Records.

75. Green, *Nineteen-Two in Vermont*, 21.

76. Ibid., 154.

77. Ibid., 34.

78. *New York Times*, August 31, 1902, 3.

79. https://www.sec.state.vt.us/media/48806/McCullough1902.pdf.

80. Joseph Battell, *The Present Crisis: Shall Private Gain Be Tolerated in the Sale of Intoxicating Liquors? An Appeal to Vermont Voters* (n.p.: ca. 1902), 10.

81. Joseph N. Harris, *Prohibition, or Local Option?* (Ludlow, VT, 1902), 4. UVM Special Collections (HV5086.V5 H36 1902).

82. *Literary Digest*, February 14, 1903, 218.

83. Vermont State Archives, Caledonia County Court, Box 74, Folder 10 #2596, *State v. G. Ceruti.*
84. "The Local Option License and State-Wide Prohibition," University of Vermont Bailey Howe Library, Special Collections, Wilb HV5086.VS T69, 1908.

CHAPTER 9

85. *Vermont Phoenix,* December 8, 1905, 3.
86. *Biennial Report of the Attorney General of the State of Vermont* (Rutland, VT: Tuttle Company, June 30, 1906), 10.
87. *St. Johnsbury Caledonian,* May 23, 1906; *Chronicling America.*
88. *Bennington Evening Banner,* April 28, 1909; *Chronicling America.*
89. *New York Templar,* August 15, 1908, 12.

CHAPTER 10

90. *Burlington Free Press,* "1914: Wood Alcohol Deaths in Bristol," August 1, 2014.
91. Ibid.
92. *Buffalo Medical Journal,* December 1914, 303.
93. Ezra Kennedy, *Pharmaecutical Era,* December 1914, 549.
94. *Burlington Free Press,* August 1, 2014.
95. Ibid.
96. Ibid.
97. Ibid.
98. Samuel Hand, *The Star That Set: The Vermont Republican Party, 1854–1974* (Lanham, MD: Lexington Books, 2002), 106.
99. Jack Salisbury, *Richford, Vermont: Frontier Town, the First Hundred and Fifty Years* (Canaan, NH: Phoenix Publishing, 1987), 117.
100. http://www.northlandjournal.com/stories/stories32.html.
101. Meg Ostrum, ed., *Visit'n: Conversations with Vermonters,* vol. 7, November 2001, Collected by the Vermont Folklife Center, 8–9.
102. Ibid., 17.
103. *Burlington Free Press,* "Midnight Run: Lake Champlain and Boat Load of Rum," March 28 1993, living section.
104. *St. Albans Daily Messenger,* September 2, 1915, 7.
105. Vermont Historical Society, Verte-Montagne Prospectus.

106. Kendrick Clements, *The Life of Herbert Hoover: Imperfect Visionary, 1918–1928* (New York: Palgrave Macmillian, 2010), 404.
107. Vermont State Archives, Lamoille County Court, #5059 Box 23, F 11, *State v. EG Foss*, 1926.
108. *St. Albans Daily Messenger*, October 18, 1922, 3.
109. Vest Orton, *Proceedings of the Company of Amateur Brewers* (n.p.: privately printed, 1932), University of Vermont Special Collections.

CHAPTER 11

110. http://womenshistory.vermont.gov/News/FranklinCountyDrivingTour/Richford/tabid/87/Default.aspx; Ostrum, *Visit'n*, 10.
111. Ibid.
112. Ibid.
113. www.newenglandhistoricalsociety.com/queen-lill-made-vermont-famous-booze-broads.
114. http://womenshistory.vermont.gov/News/FranklinCountyDrivingTour/Richford/tabid/87/Default.aspx.
115. Ibid.

COCKTAIL RECIPES

116. *Middlebury Register*, September 21, 1875, 1.
117. Ibid.
118. http://www.pnas.org/content/112/19/5893.full.
119. *Reporter*, January 2, 1809, 3.
120. *Middlebury Register*, September 21, 1875, 1.

INDEX

INDEX

Index

ABOUT THE AUTHOR

Adam Krakowski is a decorative and fine arts conservator in Quechee, Vermont. He holds a BA in art history, with a minor in museum studies, and an MS in historic preservation from the University of Vermont. He has worked at museums, historical societies, art galleries and restoration firms all over New York and New England. Adam co-authored *Vermont Beer: History of a Brewing Revolution* (The History Press, 2014) and writes for *Yankee Brewing News*, a brewing industry newspaper. In 2010, he was the recipient of the Weston Cate Jr. Research Fellowship from the Vermont Historical Society on the project "A Bitter Past: Hop Farming in Nineteenth-Century Vermont." His work has appeared in the *Burlington Free Press*, the *Communal Studies Journal* and the *Vermont History Journal*, among other publications.